D0595123

PADUCAH
WALL to WALL
Portraits of Our Past
History in Dafford Murals

© Copyright 2020 Paducah Wall to Wall, Inc. All Rights Reserved.
All Paducah Wall to Wall mural images are copyrighted by Dafford Murals and Paducah Wall to Wall, Inc.
Reproduction without permission is prohibited.

Paducah Wall to Wall, Inc is a 501 (c) 3 all-volunteer organization working to create and maintain the integrity
of Paducah's magnificent Dafford Floodwall Murals. Phone: 270-519-1321 | www.paducahwalltowall.com

The Paducah Ambassador program was created by Mayor Gerry B. Montgomery in January of 1988. Since then, the all-volunteer "Red Coats" have welcomed millions of visitors to Paducah, her beloved river city.

Dedicated to Geraldine Biggs Montgomery

Dr. Wally and Gerry Montgomery are Paducah treasures. Dr Wally (1936-2019) enjoyed sharing Paducah's history and giving tours along the floodwall images. As a beloved Paducah surgeon and philanthropist, he supported and actively promoted this UNESCO Creative City.

Paducah Wall to Wall is dedicating this 25-year celebration publication to Geraldine Biggs Montgomery. Her visionary leadership in our community, region and state is immeasurable.

Gerry (Paducah's Mayor from 1988-1996) has always known that great things were happening in this creative city. She envisioned ribbons of colorful images lining Paducah's riverfront. In the early 90s, before the Dafford mural project ever began, she and Bill Schroeder would talk about how Paducah could look in 2020. And here we are, celebrating the 25th painting season of Dafford Murals along three blocks of Water Street.

In honor of Wally and Gerry's dedication and contributions to Paducah, their friends and family have made this publication possible.

Paducah Wall to Wall Title Panel

Paducah Wall to Wall, portraits of our past, commenced in the spring of 1996 and has been researched, designed and painted by the extraordinary team of Dafford muralists. Painted sepia-toned images of historical scenes provide the backdrop for the title. The mural depicts flora and fauna that are indigenous to Kentucky as well as the silhouette of a cardinal, the state bird. The names of Robert Dafford's team of talented artists who have worked diligently on the project are listed beneath his name. The Dafford Mural team, based in Lafayette, LA, spends a couple of months each year in Paducah, painting and maintaining the project. They and the Floodwall Mural Advisory Board were dedicated to authenticity of each creation. Three blocks on the city side of the floodwall were completed in 2007.

Sponsored by the combined efforts of the Floodwall Mural Advisory Board and individual mural sponsors.

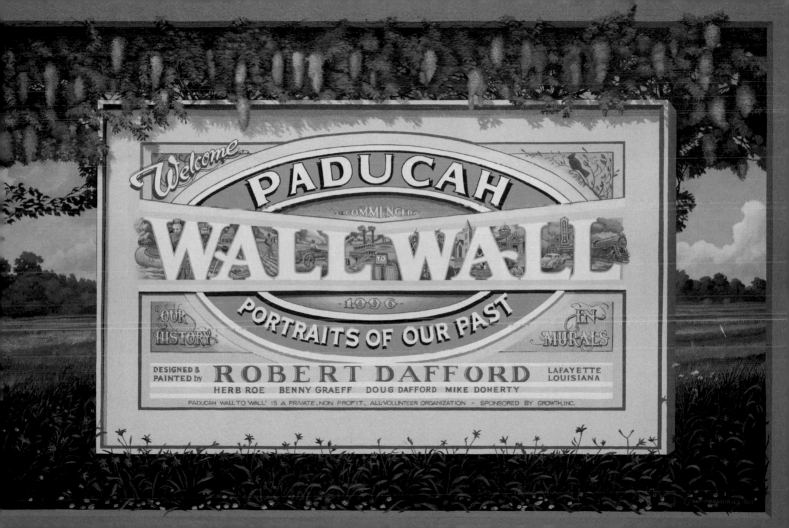

Harley History in Paducah, Kentucky

The centerpiece of this mural is the February 1948 cover of the Enthusiast magazine featuring officers David Drew and Jullian Pryor Slaughter on their Harleys flanking the statue of Chief Paduke. Also shown are: Paducah motorcycle racer "Tennessee Slim" Mayo; former Hank Brothers True Value Hardware owner Gus Ed Hank, Jr., who was a dispatch rider aboard a Harley in World War II; and members of Kentucky's five Harley Owners Group chapters on their bikes.

Sponsored by the 2001 Kentucky State Harley Owners Group Rally Committee

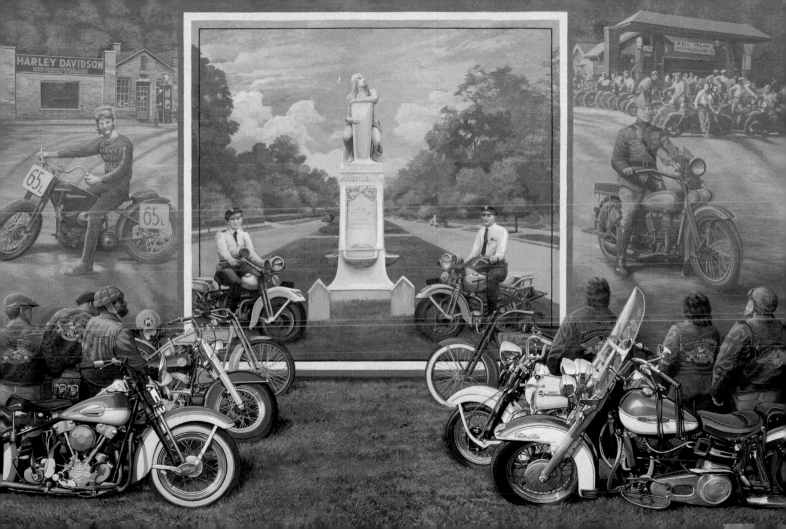

A Century of Telephone History in Paducah, Kentucky

Through the depression, a struggling telephone industry crept along with advancing technology. In 1940 progress stopped. Most personnel and materials were used to win WWII The local telephone system became outdated. In 1945 the boys came home and the Baby Boom started. Telephones were in demand. Paducah added switchboards and equipment creating the world's best telephone systems. Installing and maintaining two copper wires from the switching office to each telephone in the community, plus adding many long distant trunk circuits to other towns, were unending tasks. Paducah was the hub for switching incoming and outgoing long distant calls for the region 24 hours a day to points world wide. In 1979, the old cord switchboard was replaced by an electronic computer switching system. The Telephone Pioneers were created in 1927 and did volunteer projects to say, "We care about people and Paducah". This mural is dedicated to those who build, operate and use the telephone system.

Sponsored by G.C. Carneal, a "Telephone Pioneer" in Memory of Lottie Luigs Carneal

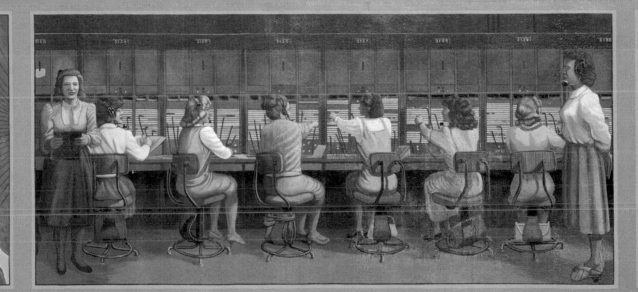

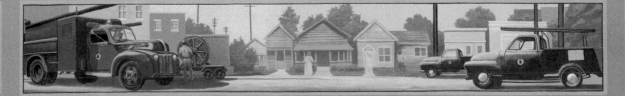

© 2000 DAFFORD MURALS

1940s Broadway Scene

This scene shows Broadway, Paducah's main street, in the 1940s when the downtown area was the center for the community's retail, business, and entertainment activities. Such downtown landmarks as the Guthrie Building, 1937 Post Office, Palmer House Hotel, Citizens Bank Building, and Columbia Theater are depicted. Cast-iron storefronts, manufactured by local foundries, remain from the earlier Victorian era when downtown Paducah experienced enormous economic growth and prosperity.

Sponsored by David & Sandra Long and Image Graphics, Inc.

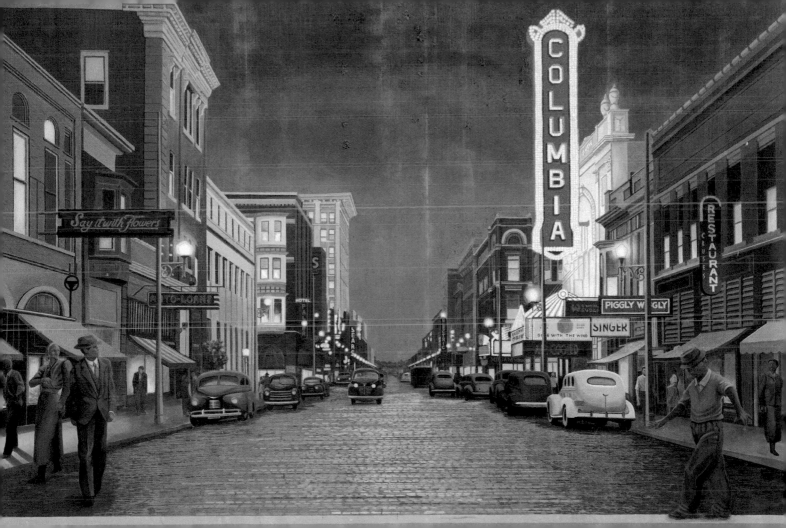

Paducah Floods

While the river has usually been Paducah's best friend, flood waters turned it into the community's enemy in 1884, 1913, and again in 1937. The area's most devastating event of the twentieth century was the flood of 1937 when 90% of Paducah was covered with flood waters. Over 27,000 residents were evacuated. After six weeks of rain in the Ohio River Valley, the river crested at 60.8 feet, nearly 11 feet above the elevation of this present sidewalk. National Geographic featured a photo of a cow on the second story porch of a Lower Town neighborhood home. Following the flood, 12.5 miles of floodwalls were erected to protect the city. Much of the floodwall is earthen mounds. (From flood photographs)

Sponsored by Schroeder Publishing Co., Inc.

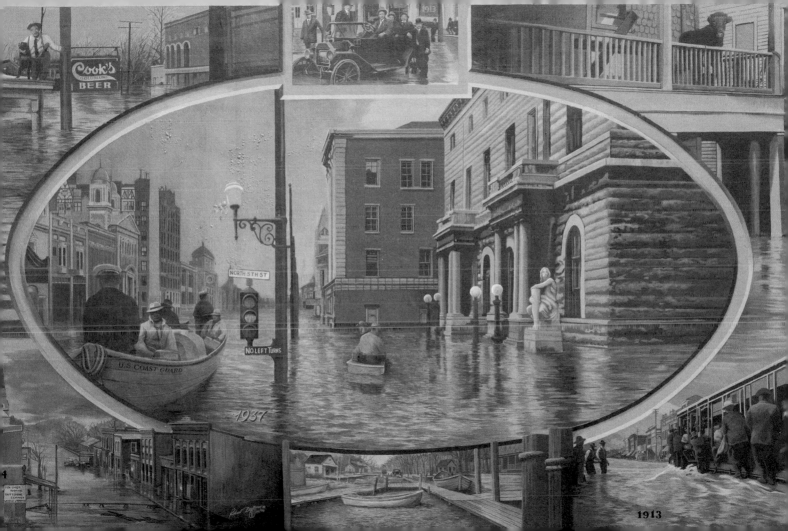

Strawberry Festival

In the early 1940s, Paducah-McCracken County was known as the strawberry capital of the world. Schools excused students to pick berries. Entire families were involved in this agricultural event. Freight cars carrying thousands of crates of berries were shipped from this region across the country. The climax of the season was the election of a Strawberry Queen and her royal court. They were featured in a grand parade on Broadway. Because of World War II, the final festival was celebrated in June 1941. (From 1939-1941 photographs)

Sponsored by Paducah Bank

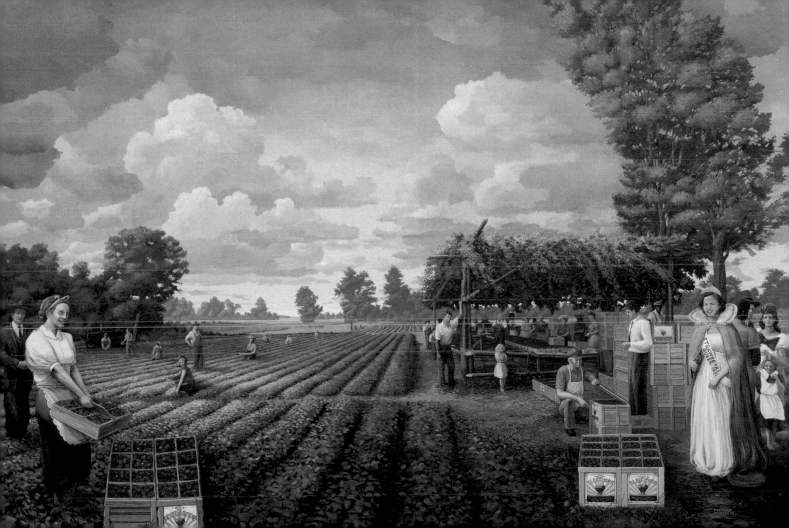

Paducah Railroads

(a) The Illinois Central Railroad Shops, located on Kentucky Avenue in Paducah, were built in 1927 for $6,000,000. At the peak, 1,447 workers were employed as this was one of the world's largest steam locomotive repair shops. In the late 1950s, the shops were converted to diesel re-manufacturing and repair, and in 1986 they were sold to a private investor. The name was changed to VMV. Doing business with U.S. and foreign railroads, VMV has made "Paducahbilt" a byword in the industry. The General Purpose or "Geep" diesel locomotive shown is typical of the type used by Illinois Central and its Kentucky successor, Paducah & Louisville Railway, Inc. Their economy of operations caused the demise of the powerful, but costly, steam engines such as the 2613.

Sponsored by Col. Wm. J. Ryan and Mrs. Bart Sullivan in Memory of Mr. & Mrs. Patrick H. Ryan

(b) In 1960, Illinois Central 2613, a Mountain type engine with 4-8-2 wheel arrangement, became the last steamer to operate on the railroad, ending a 190 year tradition. Western Kentucky, with its many coal mines, was among the last places in the U.S. to depend on steam locomotives. The 2613 was one of 20 of its type built in the Paducah Shops in 1942, and was used for both freight and passenger service. Here it is pictured at Paducah's Union Station, so called because it served both Illinois Central and Nashville, Chattanooga & St. Louis Railway passenger trains. Located near Caldwell Street, the station was for years the place to begin or end a journey or meet family and friends. The last passenger train called there in 1957.

Sponsored by: VMV Enterprises, Inc. and Paducah & Louisville Railway, Inc.

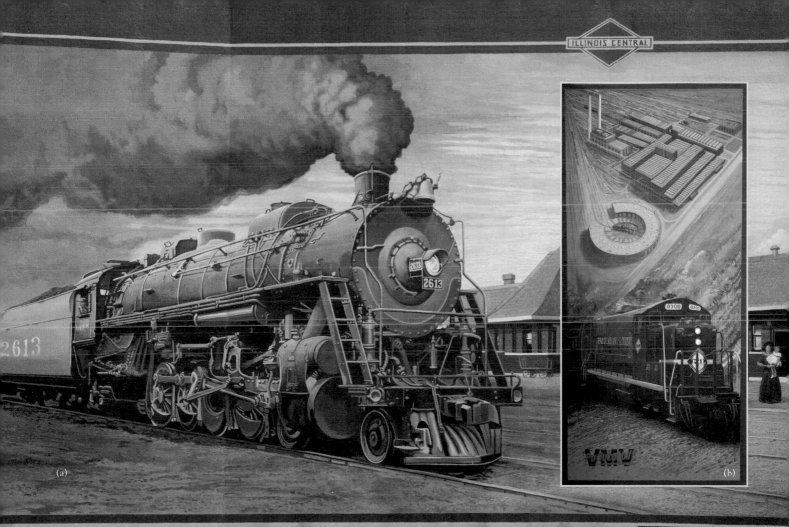

ILLINOIS CENTRAL

2613

(a)

8300

(b)

Alben William Barkley (1877-1956)

Elected McCracken County Attorney, County Judge, U.S. Representative, and U.S. Senator, Barkley served Harry Truman as Vice-President and was known as the "Veep". He was re-elected to the U.S. Senate in 1955. Barkley coined the term "New Deal" when he assisted Franklin D. Roosevelt in the reform of social programs.

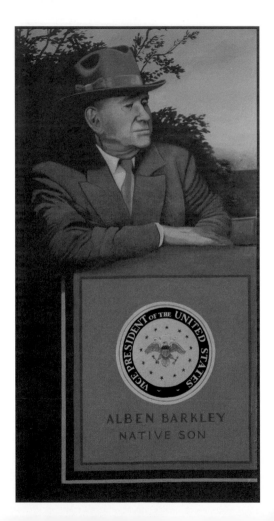

Sponsored by Eugene & Mary Louise Katterjohn

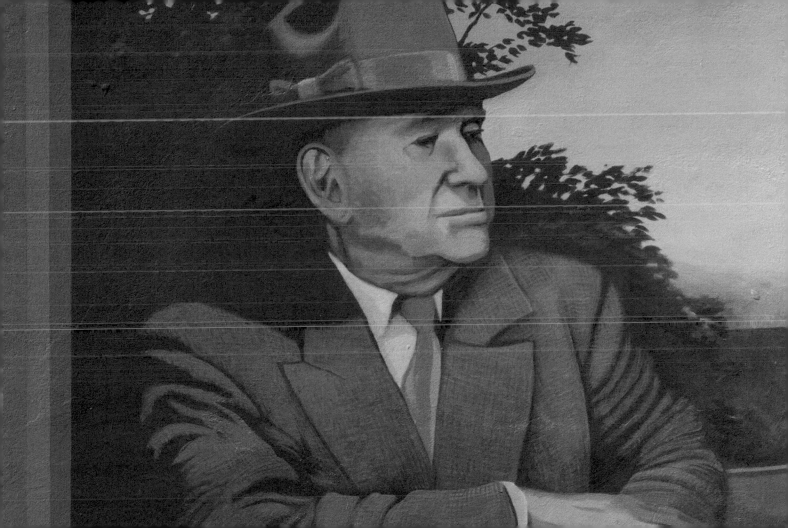

Irvin Shrewsbury Cobb (1876 -1944)

Known as the first "Duke of Paducah", Cobb became a world-class war correspondent, humorist, writer, movie actor, and radio host. Cobb defended the rights of World War I black soldiers and opposed the Ku Klux Klan in the 1920s. His Old Judge Priest stories and Paducah Plantation radio show received national acclaim. Cobb published more than 64 books.

Horse Drinking Fountain

This Horse Drinking Fountain was presented to the City of Paducah in 1907 by the National Humane Society, founded by Harmon Lee Ensign. Fountains like this were presented to cities throughout the United States. Frederick Tilghman, son of General Lloyd Tilghman and Vice-President of the Society, requested one of the fountains for Paducah. The two-ton fountain, made of polished Maine granite, provided purified city water to horses and dogs on Broadway at Tenth Street. The fountain lost its practical value as automobiles replaced horses.

Sponsored by Eugene & Mary Louise Katterjohn

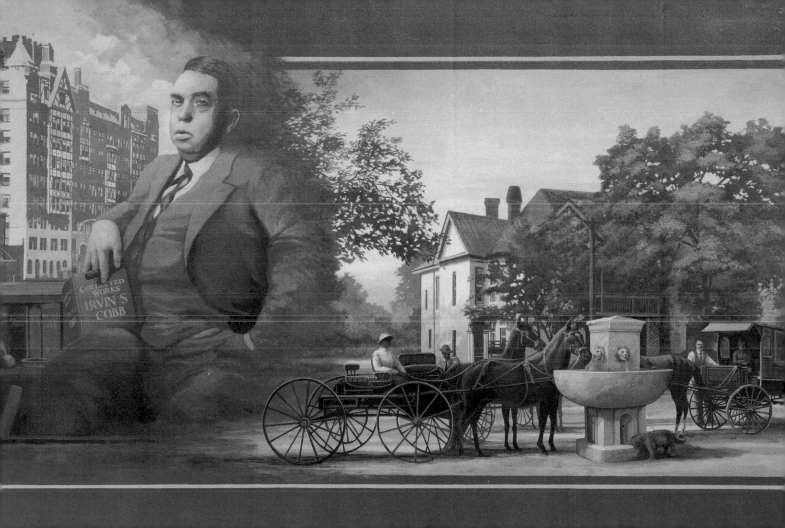

Fire Station

This building served as Fire Station #5, at 17th and Broadway, from 1910 until 1973, when it was replaced with a modern two-bay structure. In 1910 the city had nine pieces of horse-drawn fire-fighting equipment, including the ladder-hose wagon and the steam pumper shown here. Paducah had organized a volunteer fire company in 1840. Paid fire fighters assumed duty in 1882. The first motorized fire truck, an American LaFrance, was put into service in 1913, and is now on display in the William Clark Market House Museum. (From 1910 photographs)

Sponsored by: Turner Publishing Co.

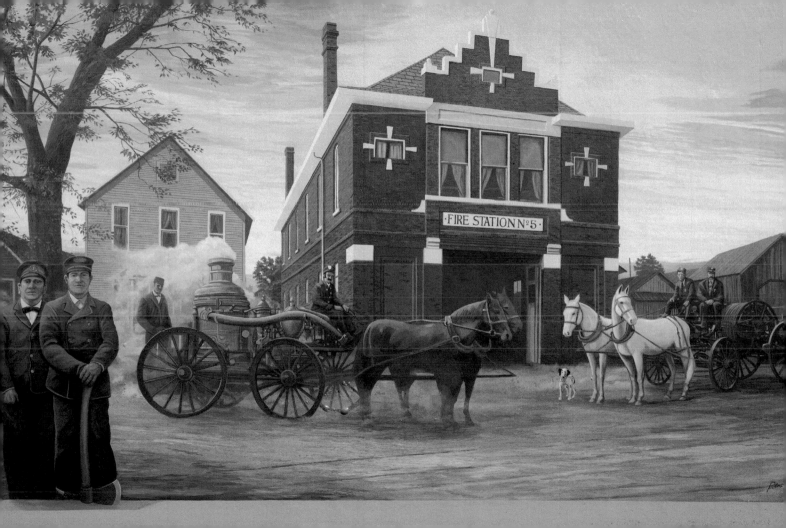

FIRE STATION N° 5

Market House

Gen. William Clark, the founder of Paducah, designated the Second Street area as a location for public affairs. The original name for Second Street was "Market", reflecting its use as a trading center. The original Market House was built of logs in 1836. A larger brick building was constructed on this site in 1850 and was used as a hospital during the Civil War. The present 1905 Market House was designed by W. L. Brainerd and built by F. W. Katterjohn for $25,000. In 1963 the building was converted to a cultural center, a project encouraged by the Paducah Civic Beautification Board. The Market House is listed on the National Register of Historic Places. Today it remains the center of cultural activity in downtown Paducah.

Sponsored by Gus Ed & Joan Hank

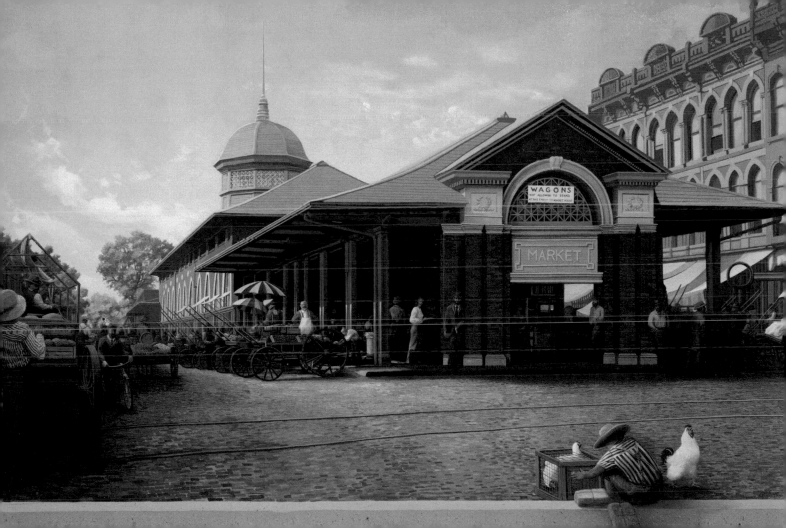

African-American Heritage, Paducah, KY

The August 8th Emancipation Celebration is held annually in Stuart Nelson Park. Nelson was a graduate of Lincoln High School, commissioned officer in WWI, and president of several major universities. He marched with Gandhi in India and with Dr. King in Alabama. Burks Chapel AME, 7th and Ohio, ran the first school for Negro children funded by black Paducah residents around 1878. Tuition was 25¢. Despite opposition, Dr. Dennis H. Anderson founded West Kentucky Industrial College, 1909-1911, to train black teachers. By 1938, it was the third largest black junior college in America. Lincoln Elementary School, built in 1894, later became Lincoln High School, a center for black education and community activity until the 1960s. After integration of Paducah's schools, it became Whiteside Elementary School. Rowlandtown School is one of several area structures containing 90 pound, 18 inch long solid concrete blocks developed by Charles and Ed Reynolds.

Sponsored by Citizens of Paducah

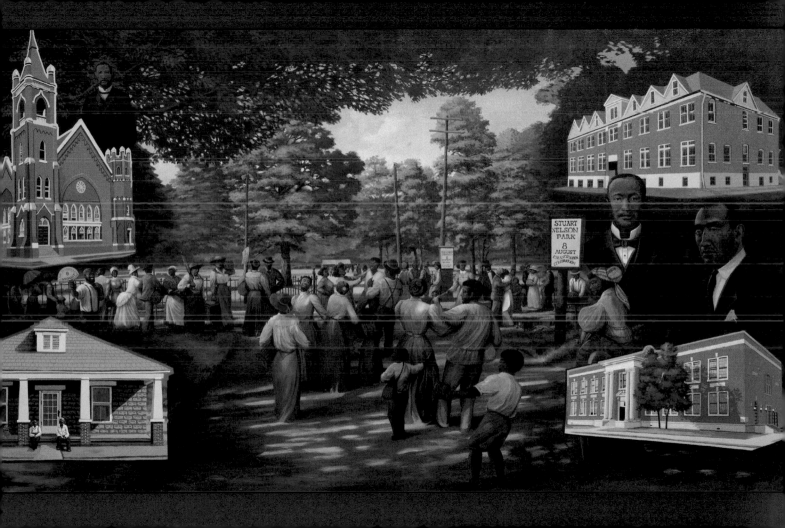

Civil War, Paducah, Kentucky

In March 25, 1864, Confederate Gen. Nathan Bedford Forrest raided Paducah intent on disrupting communications and destroying or carrying off as many Union military supplies as possible. Shown: Confederate assault on Ft. Anderson led by Paducahan Col. A.P. Thompson, killed within sight of his home. In the distance are burning military stores. From the river, Union gunboats PEOSTA and PAW-PAW give supporting fire for the fort. Kentucky was a slave state but overwhelmingly pro-Union. Paducah, however, was strongly pro-Confederacy. Gen. Lloyd Tilghman, a Paducah resident, left here in summer 1861 to raise the 3rd Kentucky Regt., Conf. States Army. He was killed in action during the 1863 Vicksburg Campaign. Union Gen. U.S. Grant occupied Paducah on Sept. 6, 1861, building a pontoon bridge across the Ohio River to the Illinois shore. Ft. Anderson, was built and named after Kentuckian and Ft. Sumter commander Maj. Robert Anderson. Attacked March 25 and April 14, 1864, the fort was successfully defended by both white and black troops commanded by Col. Stephen G. Hicks of Illinois. Shown patrolling off Paducah in 1862 is the gunboat U.S.S. Tyler. In the spring of 1864, African-Americans were recruited in Kentucky for federal service as "U.S. Colored Volunteers". The 8th Colored Artillery (Heavy) was raised almost exclusively in Paducah as were elements of five other black regiments.

Sponsored by David & Ann Denton and Dick & Jane Walker

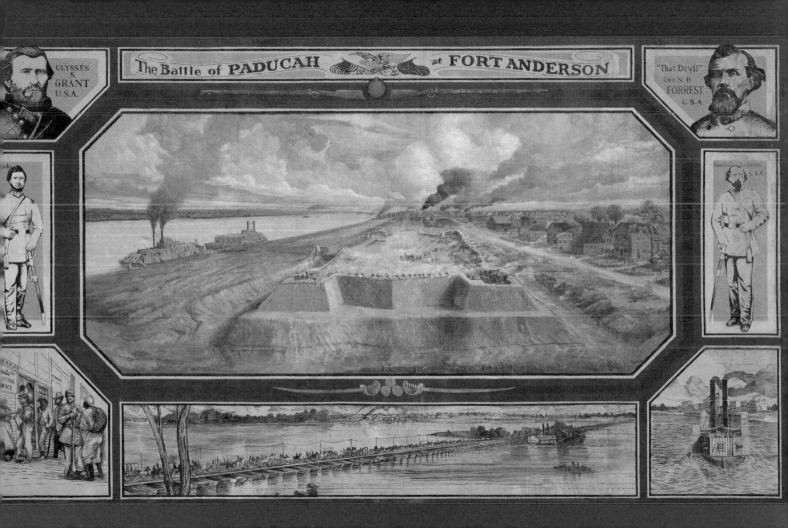

The Battle of PADUCAH at FORT ANDERSON

ULYSSES S. GRANT U.S.A.

"That Devil" Gen. N. B. FORREST C.S.A.

Gen. Lloyd Tilghman C.S.A.

Paducah's Early River Industry

Paducah's river industry was the city's life blood. Steamboats and tobacco were critical to the area's economy in the late 1880s. Mule-drawn transfer wagons moved hogshead barrels of tobacco that weighed around 1,600 pounds each. Nearly 20,000 barrels were stored annually in the area for two to three years. Steamboats carried mixed cargo and passengers. Paducah was a major port and distribution center because of its strategic location at the confluence of the Ohio and Tennessee Rivers and close proximity to the Mississippi and Cumberland Rivers. (From an 1890's photograph)

Sponsored by Paducah-McCracken County Riverport Authority

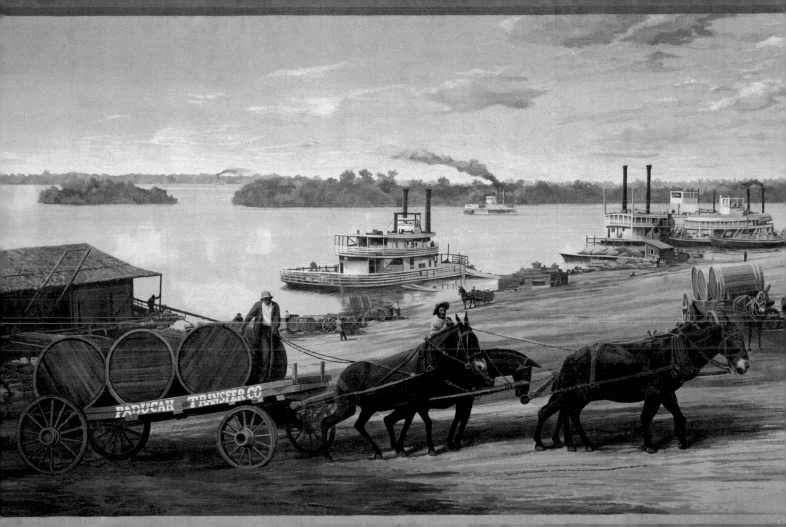

Paducah's Antebellum Religious Institutions

Paducah architecture reflected the settlers' different religious faiths. These institutions helped unite the early settlers of the community. Broadway United Methodist Church is the oldest, founded 1832 at 4th and Broadway. It relocated to the southeast corner of 7th and Broadway in 1875, and again across the street to the present location in 1896. The building, pictured above, was destroyed by fire in 1929, and was rebuilt in 1930. U.S. Vice-President Alben W. Barkley and Judge William S. Bishop, old Judge Priest of Irvin Cobb's stories, were members. Other historic religious institutions established before 1865 are, clockwise from upper right: First Christian, 1849; St. Francis de Sales Catholic, 1849; Grace Episcopal, 1848; First Baptist, 1840; First Presbyterian, 1842; St. Matthew Lutheran, 1856; Temple Israel, 1864; and Washington Street Baptist, 1855.

Sponsored by a Friend of Broadway United Methodist Church

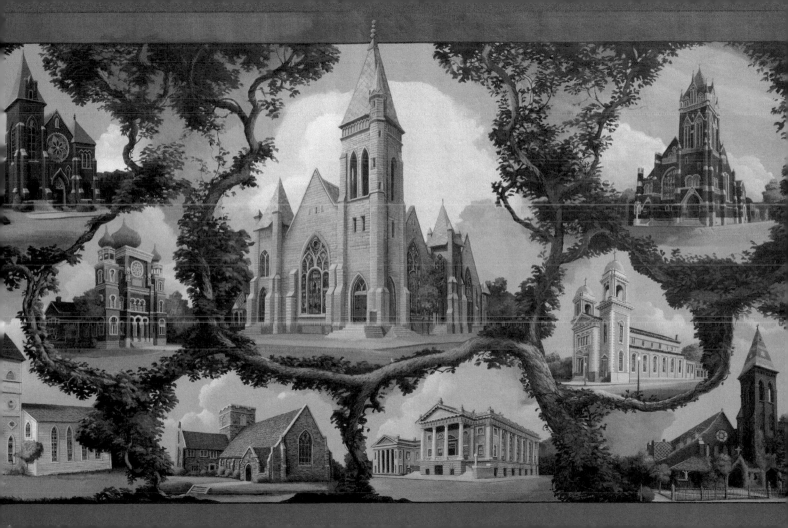

Paducah 1873 - Bird's Eye View

It was common practice in post-Civil War America for communities to be depicted in bird's-eye views showing buildings, people, animals, boats, rivers, streams and railroad lines. This mural recreates an 1873 Bird's-Eye View Map of Paducah that now hangs in the Market House Museum. After surviving the Civil War with only minor damage, Paducah in 1873 was a prosperous and growing city. Much of the community's prosperity was due to its river and rail facilities, many of which are illustrated in this mural. By 1900, Paducah had grown to be one of the largest manufacturing and distributing centers in Kentucky and was classified as a 2nd class city.

Sponsored by Rex Holland, Jr., Richard Holland and Mary Leigh Holland Stiff in memory of their parents, Dr. Rex and Jane C. Holland

34

1. Court House
2. Male Seminary
3. County Jail
4. Public Schools
5. Hospital
6. Railroad Depot
7. Hub & Spoke Factory
8. Fort Anderson
9. Vaughn Tobacco Whrs.
10. Kay, Cobb & Co. Tobacco
11. Allard & Son Flour Mill
12. Tobacco Manufactory
13. McKnight Planing Mill
14. Langstaff, Orm Planing & Sawmill
15. Marine Ways
16. Linning & Jackson Foundry
17. Rolling Mill
18. Phoenix Foundry
19. Furniture Factory
20. Episcopal Church
21. Baptist Church
22. Methodist Church
23. Christian Church
24. Presbyterian Church
25. Cumberland Presbyterian
26. Lutheran Church
27. Catholic Church
28. Jewish Synagogue
29. N. Methodist Episcopal
30. Baptist Colored Church
31. Methodist Colored
32. Market
33. McCutchen House
34. Smedley House
35. Langstaff House
36. Bank

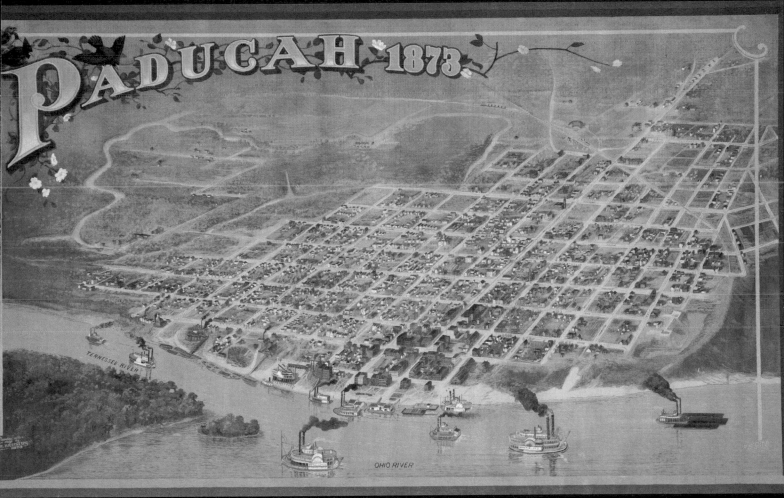

PADUCAH 1873

TENNESSEE RIVER

OHIO RIVER

The First Log Cabin

In 1884, Robert S. Davis recalled that the first cabin was a round-log cabin, about sixteen feet square, erected by the Pore brothers, James and William, in April of 1821. Davis identified four families living at the site at that time. Records in Livingston County affirm that a town called "Pekin" claimed the site. In a letter to his son, William Clark wrote that he chose to re-name Paducah to honor a tribe, the Padoucas, that once was quite large but had been decimated by contact with Europeans. Despite its late start, Paducah soon became the largest city in the region due to the favorable location on the rivers and later, as the terminus of the New Orleans and Ohio Railroad which was connected to lines running south in 1860.

Sponsored by Marshall & Marcia Nemer and Caroline Yaffe in memory of Mr. & Mrs. Samuel H. Finkel

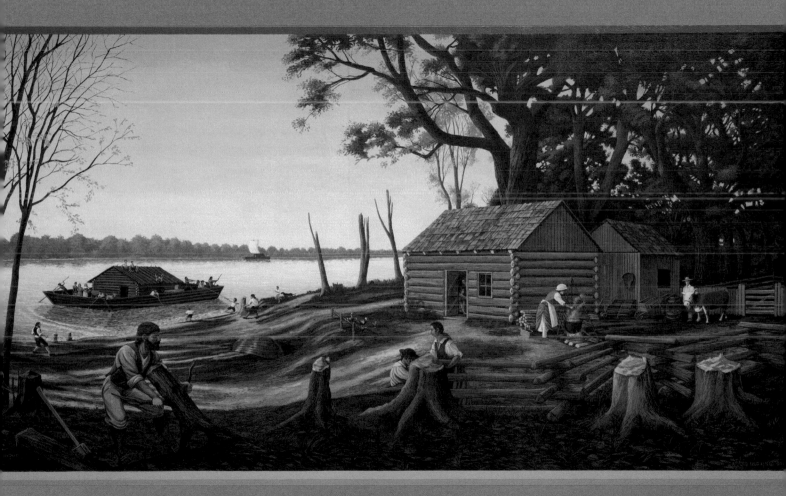

William Clark

William Clark, 1770-1838, a soldier, explorer, Superintendent of Indian Affairs, and Governor of Missouri Territory, is best known for his role in the Lewis and Clark voyage of discovery up the Missouri River in 1804. William got title to the site at Paducah on October 13, 1827 from the Kentucky courts. Clark sent his agent, George Woolfolk, to displace "squatters" from the site of Paducah and to survey it. Previously, the contested site had been called Pekin. The Clark plat of the town was entered into McCracken County records on June 18, 1830. The Clark claim was not clear until 1844 when the Porterfield Script case was heard before the U.S. Supreme Court. The rival claim was based on a military warrant, which usually superseded treasury warrants, however, the Clark claim was upheld. The first lots were sold in 1830.

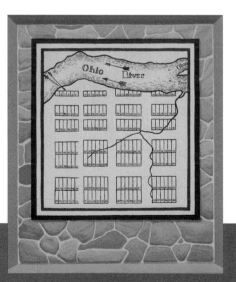

Sponsored by James Wheeler Hank, Charles Ferguson Hank
& Hank Brothers Hardware

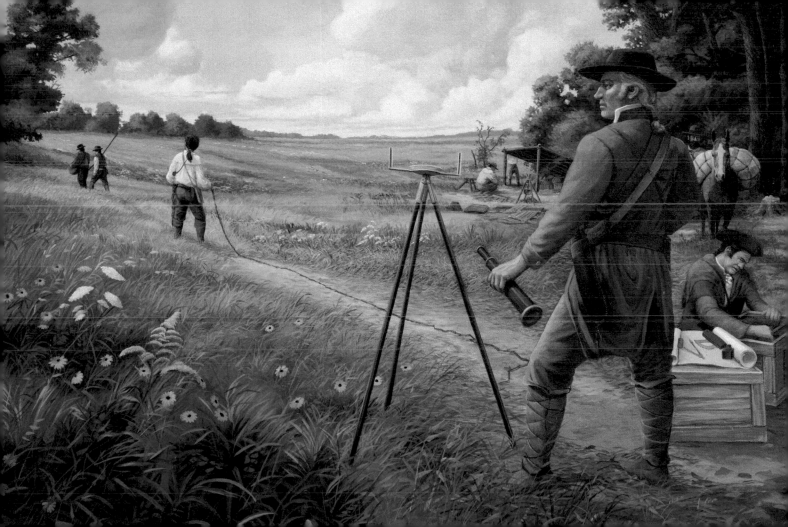

George Rogers Clark

George Rogers Clark, 1752-1818, a Virginia surveyor, came to Kentucky to seek his fortune. He thwarted the claim of Richard Henderson and Daniel Boone to the territory west of the Appalachians in 1776 by persuading the Virginia legislature to create Kentucky county. In 1778, Governor Patrick Henry ordered Lieutenant Colonel Clark to attack British posts along the Ohio. Clark's command of about 200 captured for Virginia the Northwest Territory (all U.S. territory east of the Mississippi, north of the Ohio, and west of the Appalachians). While in route to attack Kaskaskia, Clark noted the potential for a town at the mouth of the Tennessee River. Later, he used a Virginia treasury warrant dated September 15, 1795 to claim 37,000 acres at the mouth of the Tennessee River. Clark died in 1818 deeply in debt, so title to this site eventually went to younger brother, William, of Lewis and Clark fame.

Sponsored by James Wheeler Hank, Charles Ferguson Hank & Hank Brothers Hardware

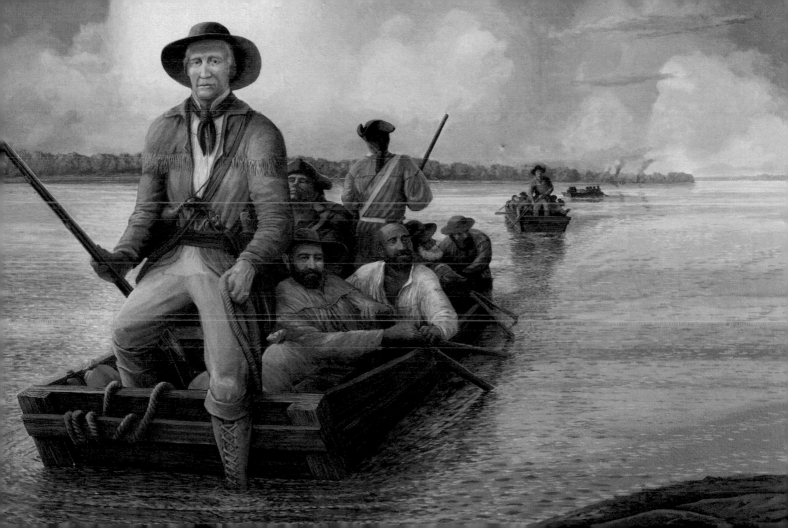

Paleo and Archaic Indians

Evidence of Native Americans in the lower Ohio Valley includes the Paleo Indians, who lived in this area near the end of the last Ice Age, about 13,000 years ago. Often called Big Game Hunters, they were efficient, nomadic, hunters, fisherman, and gatherers who also made distinctive fluted projectile points.

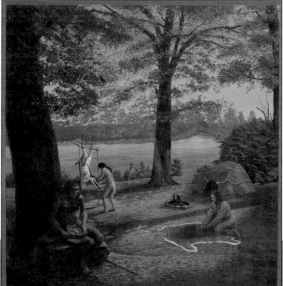

Indians of the Archaic Tradition, around 3,000 years ago, were the first in the area to begin domesticating plants like goosefoot, sunflower, sump weed, marsh elder, pigweed, squash and gourds, and traded long distances for exotic resources like galena and copper. They were the first to live in permanent villages where they provided cemeteries for their deceased.

Sponsored by Bill and Meredith Schroeder

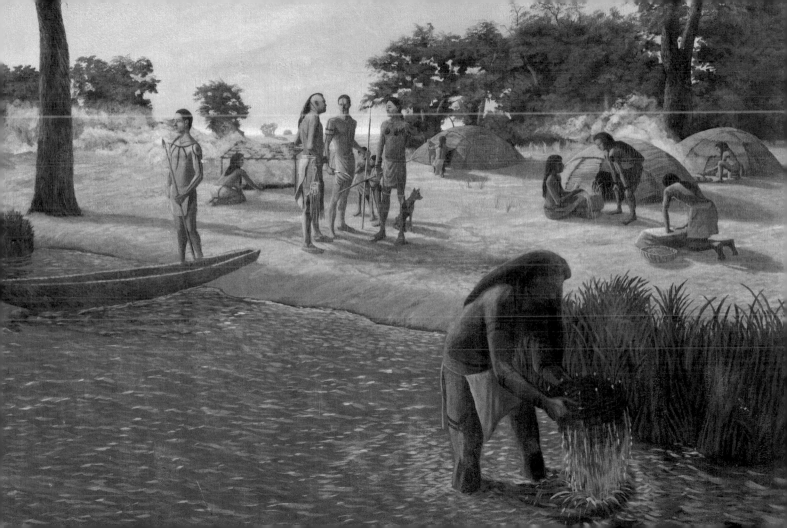

Woodland and Mississippian Indians

Woodland Tradition Indians, around 2,000 years ago, developed exotic mortuary cults, built burial mounds and effigy earthworks, and traded great distances for obsidian, copper, mica, and conch shells. They explored and exploited the caves of south central Kentucky where they mined gypsum, aragonite, mirabilite and selenite crystals. They made the first clay ceramic vessels, relying equally upon hunting, gathering, fishing and horticultural pursuits for food.

Sponsored by Bill and Meredith Schroeder

The last prehistoric cultural tradition, the Mississippian, around 700 years ago, exhibit a series of parallel, if not diffused cultural traits originating from Mesoamerica, including the bow and arrow, corn agriculture, truncated (flat-topped) mounds for use by a priestly elite and civil authorities, town plazas, and many similar iconographic designs as found at Kincaid and Wickliffe Mounds.

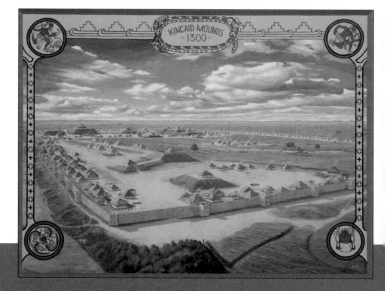

Sponsored by Robert Dafford as a gift to the City of Paducah

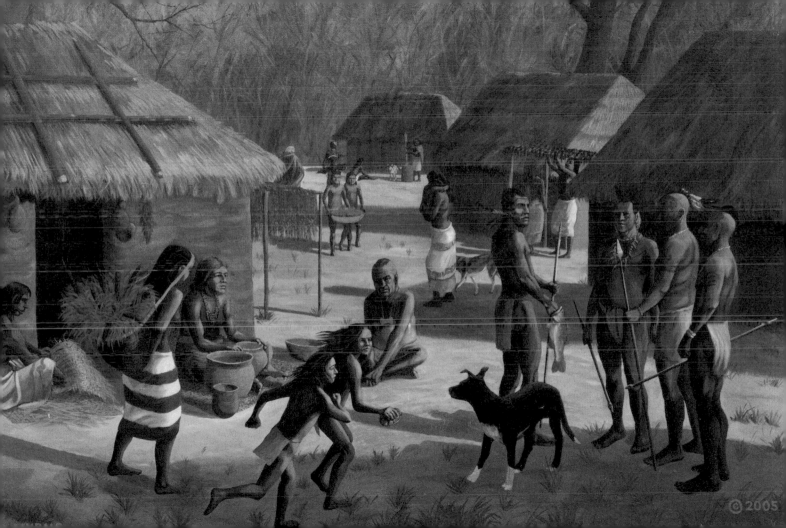

Lewis and Clark Expedition

The Chickasaw tribe claimed all of Kentucky and Tennessee west of the Tennessee River until a treaty in 1819. Therefore, on November 11, 1803, traders, trappers and Chickasaw natives took little notice of the Lewis and Clark Expedition, Corps of Discovery, as it trekked through these waters in route to the Pacific Ocean. Few ventures have surpassed their discovery. William Clark returned in 1827 to establish Paducah in honor of the Padouca Indians.

Sponsored by friends, in memory of Paducah Ambassador Charles Cissell

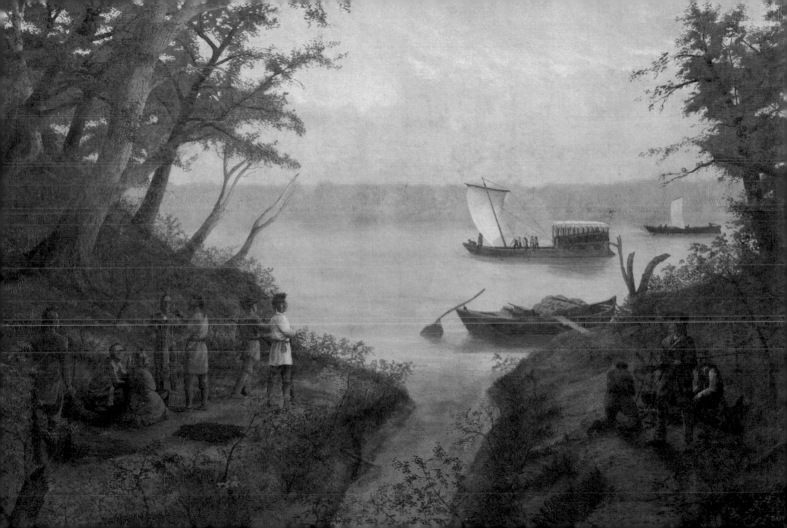

First County Seat
First County Clerk, Braxton Small

Established in 1827, Wilmington served as the first County Seat. At the age of 24, Braxton Small served as the first Clerk for McCracken County for 33 years (1825-1858). During the flood of February 1832, he removed all the records to Paducah from the original Courthouse in Wilmington by skiff boat, records were in a "cracker barrel" he used as a filing cabinet, with the important papers under his Beegum hat to keep them dry. He also served as a trustee of Paducah, selling the property to the County where the present Courthouse is located. His marriage was the first recorded in Paducah, to Grace Walters, a beautiful woman who gave birth to the first girl officially born in the county. He was a founder in Paducah's first bank, "The Exchange Bank". They are interred at the Oak Grove Cemetery.

Sponsored by Eric T. Small in memory of Erica Hilary Small

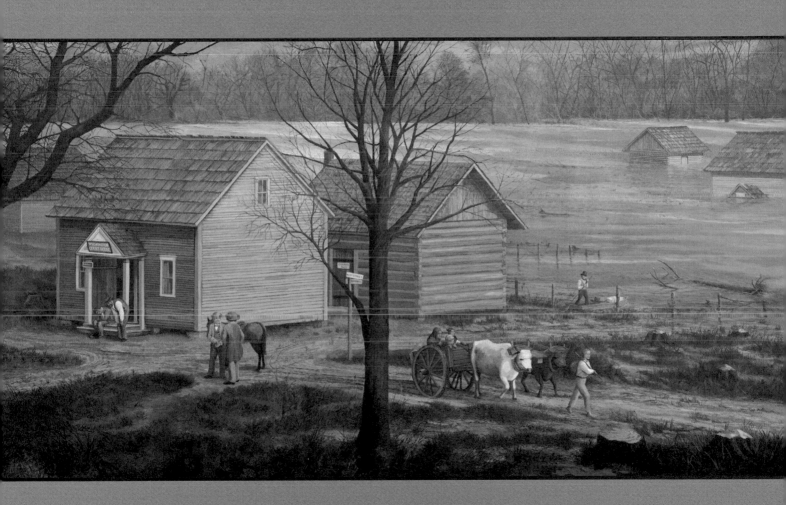

Iced Solid - Clear to Illinois!

Still recovering from the flood that was the worst disaster experienced in the United States up to that time, the new year, 1938, started with what many feared was a prelude to another debacle. At Paducah, the Ohio River froze solid. The riverfront quickly took on the look of a playground for Hans Brinker of legend. Citizens cautiously tested the ice. Seeing how deep the freeze penetrated, others followed. Finally, cars, bicycles, skates, and sober citizens made frolic. The public schools had been dismissed, and many migrated toward the foot of Broadway. All barge traffic stopped at this bustling port, until the mighty Ohio thawed.

Sponsored by McNational Inc., in business for over 100 years, and proud to be a part of the Paducah river industry

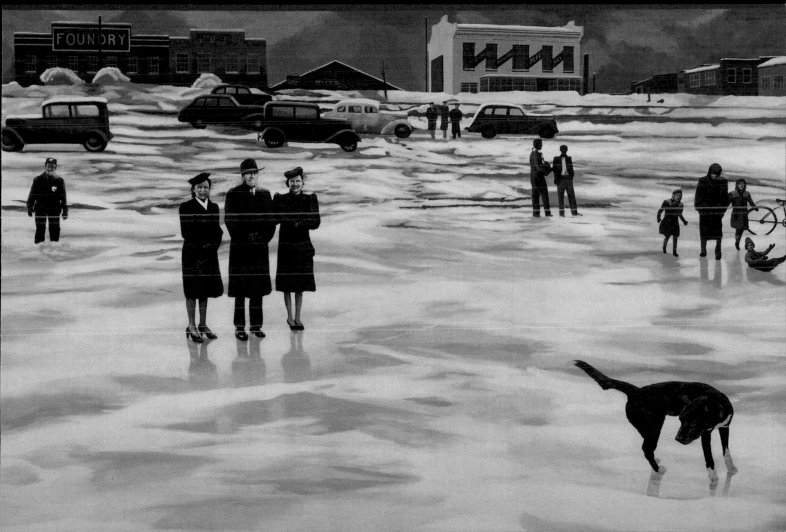

Original Marine Ways

Paducah's first heavy industry was a marine ways to build and repair river craft. Elijah Murray of St. Louis got a contract in 1843, but it did not materialize until 1853. These works have been in continuous operation every since, with a brief intermission due to the Flood of 1937. Initially, ten rail sections, each capable of holding boats 350 feet in length, were completed by March of 1854.

A cradle would be lowered down the rails and placed under the craft. Lashed securely, the vessel would be pulled up to the top of the bank so that access was had to the entire hull. Motive power ranged from teams of oxen to steam over the years before the Civil War. Currently, conventional dry docks are used. Dedicated to the Staff and Leadership of the Seamen's Church Institute for their training and support of inland river mariners.

Sponsored by the Core Users of the Center for Maritime Education: ACL, AEP/
Memco, Canal, Crounse, Ingram, Marathon, TECO, and WKN

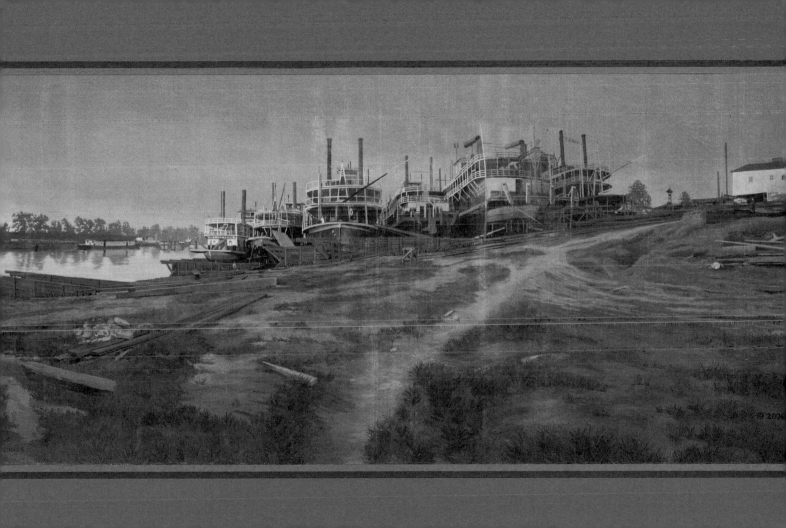

1913 Paducah Homecoming

In May of 1913, Paducah held a homecoming celebration to excite and entertain the public and to offset the negative image of the city given the nation by media reports of the flood that year. The first event had Mayor Thomas N. Hazelip welcoming the legendary Chief Paduke, portrayed by James Wheeler, giving the chief the key to the city. Wheeler arrived on the steamer G.W. Robertson at the foot of Broadway and rode his horse through the city to the federal building, accompanied by Adine Corbett, Bertha Ferguson and Ruth Hinkle, acting as Indian princesses.

The Boosters Club organized multiple events to enhance the week's festivities. Each day had a different theme for a parade and Broadway became a street fair and carnival. A flying boat added to the spectacle. Faith Langstaff won the Floral Queen contest.

Sponsored by: Bob & Bertha Wheeler Wenzel and JR and Jane W. Myre Rutter

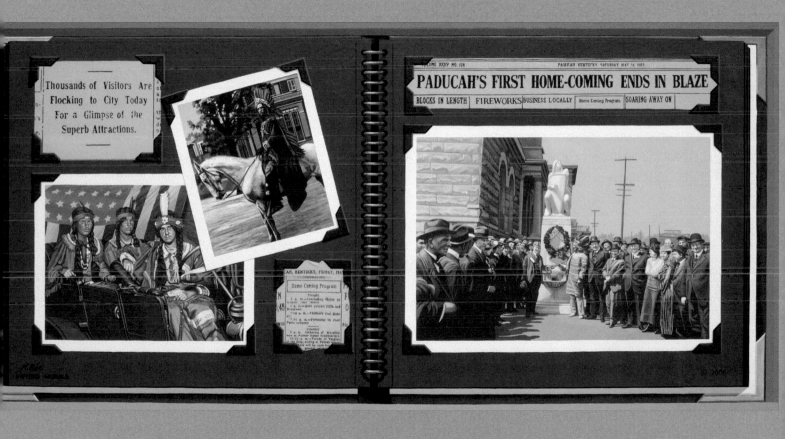

Thousands of Visitors Are Flocking to City Today For a Glimpse of the Superb Attractions.

PADUCAH'S FIRST HOME-COMING ENDS IN BLAZE

BLOCKS IN LENGTH | FIREWORKS | BUSINESS LOCALLY | Home Coming Program | SOARING AWAY ON

1912 Port of Paducah Panel 1

(a) Visitors coming to Paducah by boat in the early part of the twentieth-century would have been greeted by the hustle and bustle of a riverfront lined with hotels, warehouses, packet boat offices, lumber yards, supply houses, iron foundries, maritime industries and small businesses, all connected to the river. One of the busiest places at the riverfront was the Paducah Wharf Boat, which was permanently moored at the foot of Broadway to allow the loading and unloading of cargo and passengers. Large barrels of dark-fired tobacco, known as "hogsheads", lined the riverfront waiting to be shipped to ports in Central and South America, Europe and Africa.

Sponsored by Frederika Petter & Robert Petter, Jr. in memory of Stanley & Anna Webb Petter

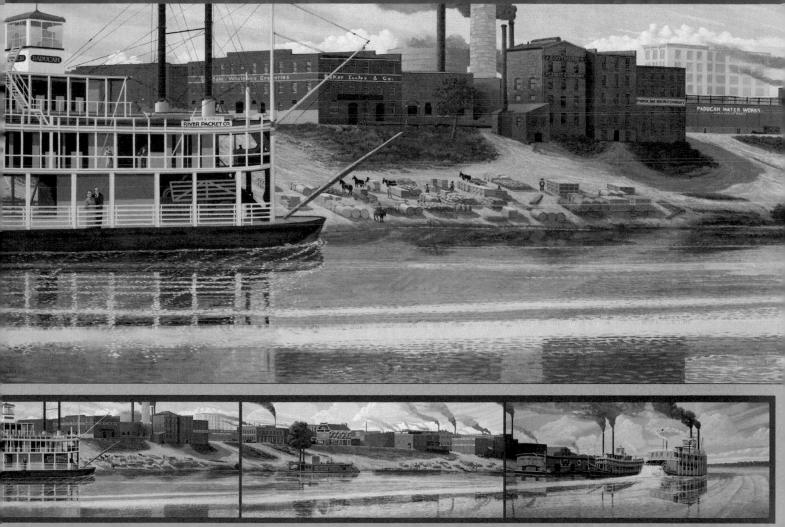

1912 Port of Paducah Panel 2

(b) Constructed in the 1840s, the two-story, Greek Revival structure overlooking the Paducah riverfront was originally the location of the Branch Bank of Louisville, one of the community's first banks. After the Civil War, the building was used for many years as a hotel before becoming the headquarters of the Henry A. Petter Supply Company in 1890. This mill and boat supply company provided provisions to packet steamers tied up at the riverfront. The Petter Supply Company remained at this site for over 100 years and is still one of Paducah's most important enterprises. In the late 1990s, the building was restored as a River Heritage Museum that celebrates the maritime history of the four rivers region.

Sponsored by Frederika Petter & Robert Petter, Jr. in memory of Stanley & Anna Webb Petter

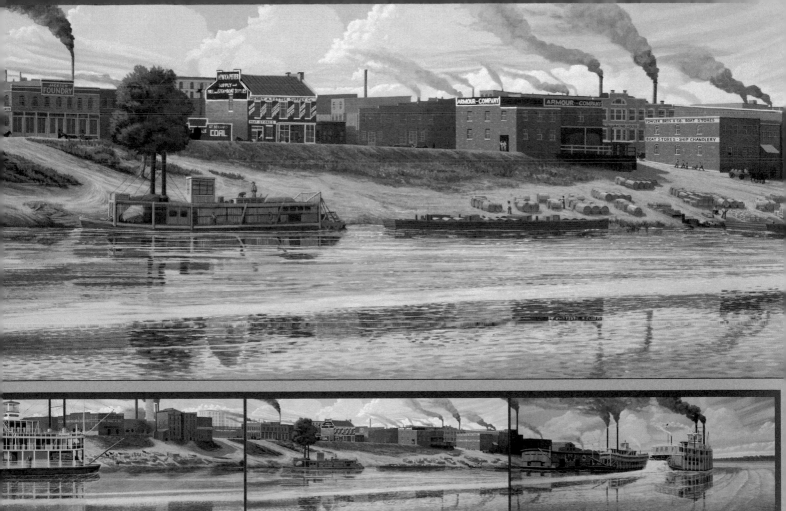

1912 Port of Paducah Panel 3

(c) Paducah's riverfront was a critical "break-in-bulk" point on the nation's inland waterways system. Cargo from deeper draft vessels, as well as passengers and mail, would be loaded and unloaded on to packet boats that ran regular routes on the Tennessee, Cumberland and Ohio rivers from Paducah. The most famous locally owned packet boats belonged to the Fowler Brothers' Company. During the heyday of river packets from 1870 to 1915, the Fowler Brothers' boats were among the fastest and best known on the Ohio River. The steamer Joe Fowler operated from 1881 to 1912 and ran from Paducah to Evansville, making the round-trip in 25 hours.

Sponsored by the Vic Speck Family

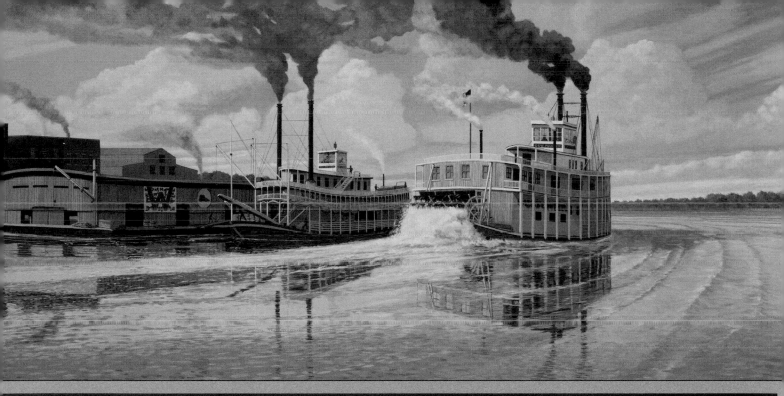
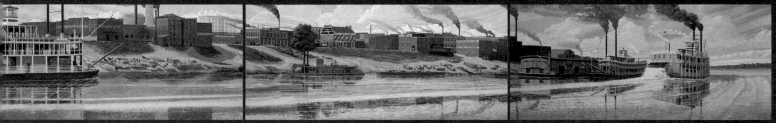

Lock and Dam 52

Lock and Dam 52, completed in 1928, is located at Ohio River Mile 938.9. This site, and Lock and Dam 53, are the only remaining movable wicket dams on the Ohio. Both will be removed when the Olmsted Locks and Dam become operational. When the navigation system was completed in 1929, there were 51 similar projects. The U.S. Army Corps of Engineers' maneuver boat raises and lowers the wooden wickets, determined by river conditions. The M/V RAY A. ECKSTEIN is shown locking downbound. The vessel, owned and operated by Marquette Transportation Co., Inc., is headquartered in Paducah and named for the company's founder.

Sponsored by Marquette Transportation Company, Inc. to honor the Eckstein family

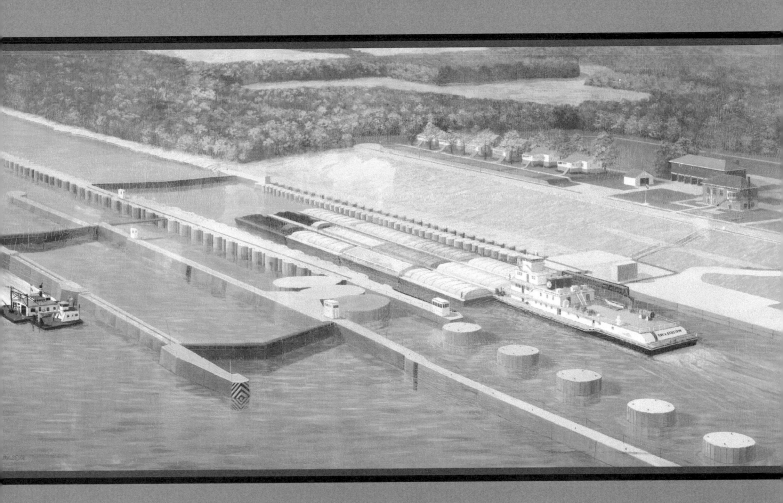

Harvesting Mussel Shells for Buttons

The riverbeds are rich with mussels whose shells, when polished, have luster suitable for processing into "pearl" buttons. In the late 19th century, mussels were harvested by brailing from the river bottoms; they were then cooked in vats for meat removal, and the shells were stockpiled on the river banks for shipment to the button factories. For many years, shell-digger camps and huge piles of shells could be seen along the banks of the Ohio and Tennessee Rivers.

The pearl button business became an important local industry when Capt. Louis Igert, Sr. moved his family to Paducah in 1920, and established the McKee Button Co. on So. 3rd Street. By 1928, the National Button Producers Association proclaimed Igert's business "the largest producer of freshwater buttons in the world".

Sponsored by the children of Louis and Imogene Igert: Jane Igert Ranna, Mary Igert Shoup, Louis Igert III, and Martha Igert Blodgett, in memory of their grandparents Captain Louis and Emma Vawter Igert

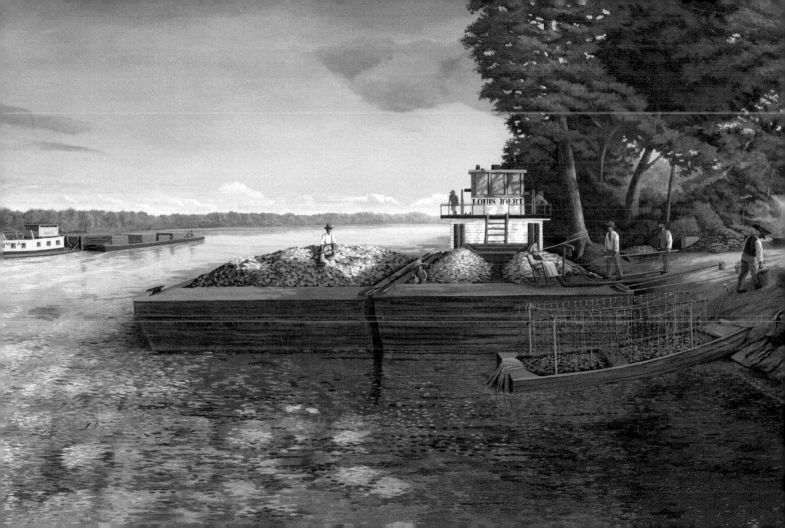

Paducah's First Floating Marine Supply Store

Paducah Marine Supply & Service was the first floating boat store on the inland waterways. Owned and operated by Hougland Barge Line, founded in 1905, moved to Paducah in 1935, it operated a complete machine and carpenter shop to service its own fleet of boats and barges as well as those of many of the family owned towing companies that called Paducah their home port. It was in service from 1945 until 1975 under the direction of Walter G. Hougland, Robert Hougland Sr., and Gresham Hougland. Hougland Barge Line built the "Boat Store" from a converted War Surplus Corp of Engineers quarters boat. These boats served as crew quarters for the dredges operated by the Corp of Engineers. Anything a towboat needed was available from Paducah Marine Supply & Service.

Sponsored in memory of Walter G. and Frances M. Hougland

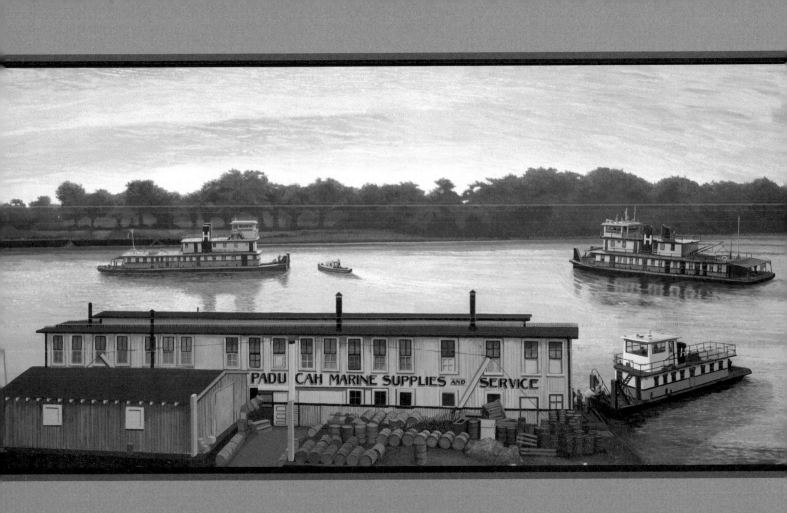

Grand Propeller

Paducah, being located at the confluence of the Ohio and Tennessee rivers and within close proximity of the Cumberland and Mississippi, is the hub of the river industry. Two major shipyards serve the Port of Paducah; James Marine and Walker Boat Yard. This mural features the M/V Craig Philip being dry-docked for wheel repairs at James Marine. Paducah's river industry is a major employer in the four rivers region. These industries perform barge and boat repairs; handle barge fleeting, shifting, cleaning and painting; provide provision boats with fuel and supplies; and train river mariners from all over the country.

Sponsored by James Marine

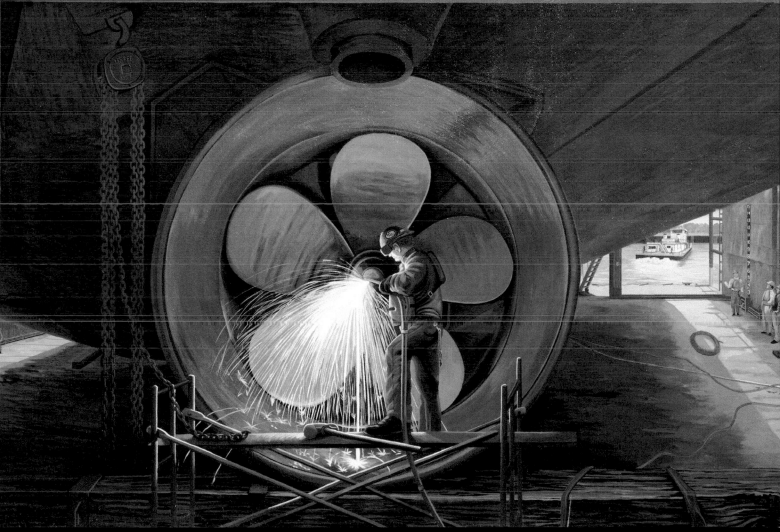

Christening of the Eleanor

Paducah has long been the foremost hub of the inland marine waterways. Thus, many towboat companies have located here. The Christening of the Towboat Eleanor is indicative of the significance of each new vessel that joins the home fleet of the Port of Paducah. The Crounse Corporation traditionally names its boats after female relatives, employees or relatives of employees. These festive events are typically attended by family and friends of the river industry. Eleanor Crounse is portrayed breaking a bottle of champaign on the towboat's bow in celebration of the Christening, December 7, 1955.

Sponsored in memory of Eleanor Buchanan and George Paull Crounse

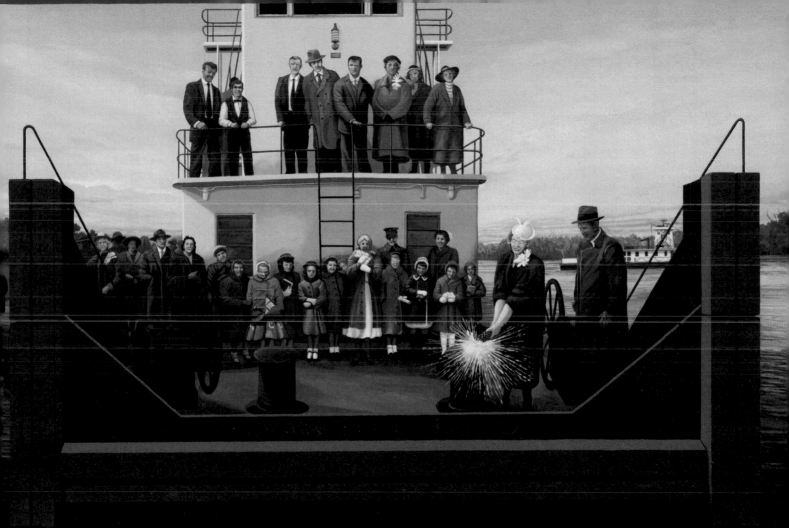

Greeting the Queens

On July 2, 1996, the City of Paducah was visited by marine royalty. All three of the Delta Queen Steamboat Company's boats docked simultaneously at the Port of Paducah. The Delta Queen, Mississippi Queen and American Queen frequent the community where they are enthusiastically welcomed by the volunteer organization of men and women who represent Paducah and McCracken County - the Paducah Ambassadors. The "Red Coats" create an extravagant panorama of color on the waterfront for the landings and departures of the majestic queens. The Ambassador program was inaugurated by Mayor Gerry B. Montgomery in January of 1988.

Sponsored by Jim Grisham in memory of Jo Grisham

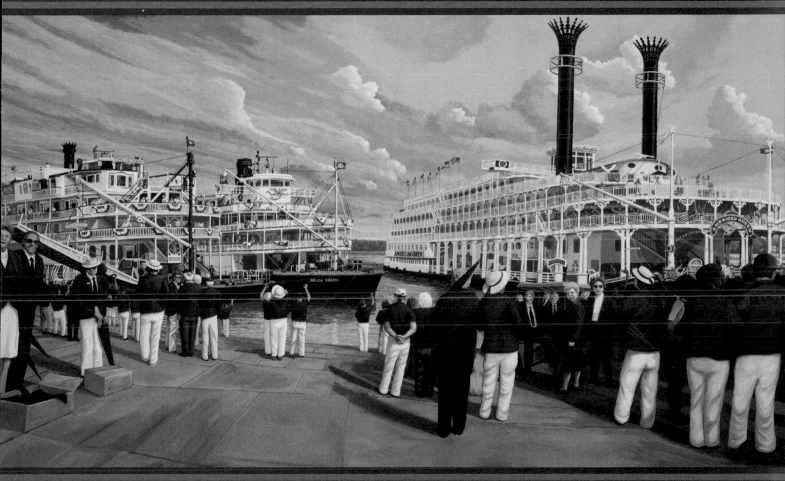

Standing Watch

This scene depicts a captain, a highly trained and skilled professional, standing his normal 6-hour navigation watch in a typical pilothouse. He is looking out over a 15-barge tow with 24,000 tons of cargo. His location is downbound, passing the Port of Paducah at the confluence of the Tennessee and Ohio rivers.

At the turn of the 21st century, Paducah has become the hub of the inland transportation system. With many towing companies calling Paducah home, the river industry is a major employer and contributor to the entire region. Every possible support service is available locally: bankers, grocers, supply houses, dry docks, machine shops, underwriters, Coast Guard offices and even a unique simulator training facility.

Paducah is truly "The Bright Star on the River".

Sponsored by William H. & Mary Dyer, Judith Dyer Cann & Sarah Dyer Johnston
in loving memory of William Wuster Dyer and Julia Igert Dyer

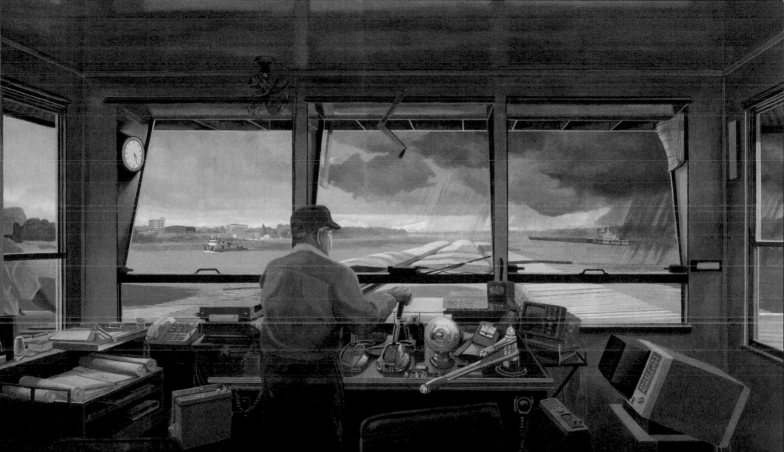

Paducah Summer Festival

In 1966, Mayor Tom Wilson, a civic-minded Paducah native, was encouraged by then Kentucky Governor Ned Breathitt, to organize a celebration of the state's bi-centennial. He envisioned festivities right on the riverfront where the city's history originated as well as throughout the town.

Wilson enlisted the help of city agencies, area businesses, and private citizens. The original festival lasted only three days but included many of the same activities that are still enjoyed years later: riverfront concerts, the Paducah Symphony, cross-river swim, hot air balloon races, Screaming Eagles' parachute show, the Fire Departments' watermelon grab, games for all ages, and the grand finale with fireworks. The Paducah Summer Festival grew to be ten days and nights of family fun, primarily focused on Paducah's beautiful waterfront.

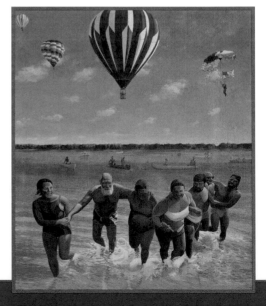

Sponsored by the late Elmer S. and Myrtle J. Breidert of St. Louis, Missouri

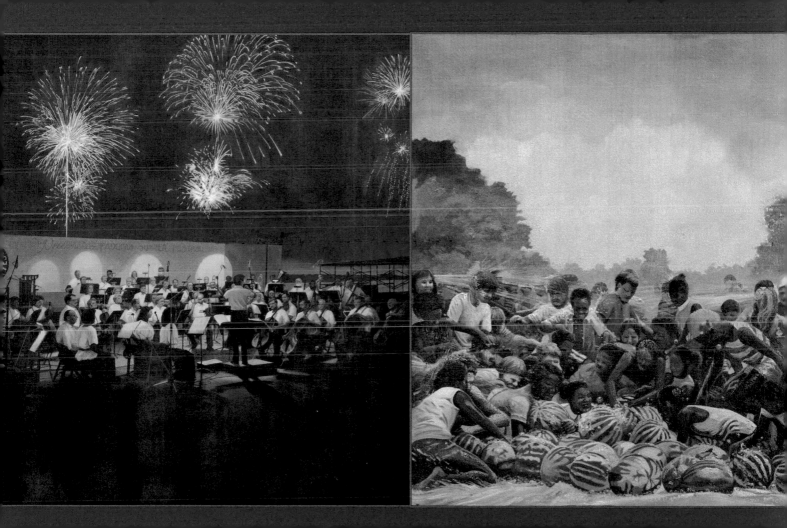

Traffic Leaving Plant Construction Site

On October 18, 1950 the U.S. Atomic Energy Commission approved the site of the former Kentucky Ordinance Works as the location for a new facility in the nation's rapidly growing nuclear production complex. Construction of the Paducah Gaseous Diffusion Plant, ten miles west of the City of Paducah, brought sudden change to the community. The local population doubled as the construction work force arrived, retail sales rose from $44 million in 1950 to $94 million in 1953, and school enrollment rose from 8,000 to 12,000 in the same period. This mural commemorates the dedication of thousands who worked for better plants, a stronger community and a higher quality of life.

This mural commemorates the dedication of thousands who worked for better plants, a stronger community and a higher quality of life.

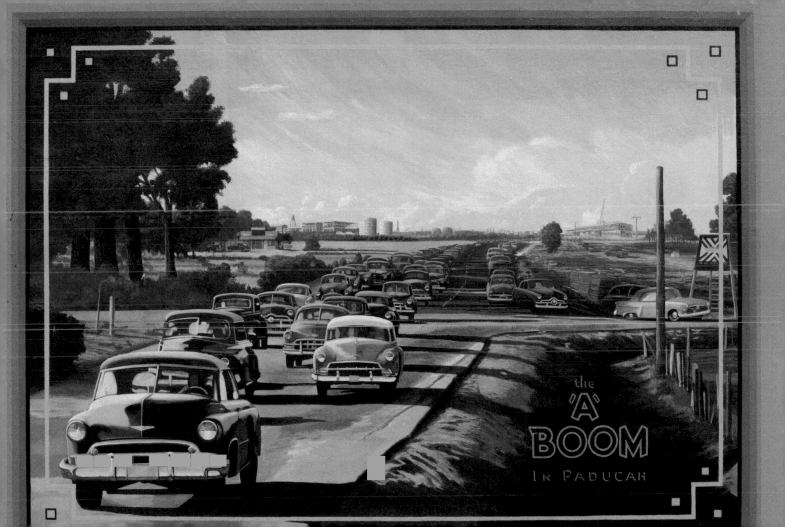

Construction Underway

Urgency was the order of the day, as construction of the Paducah Gaseous Diffusion Plant, TVA's Shawnee Steam Plant, and Electric Energy Inc's Joppa (IL) Steam Plant all began early in 1951. Recognizing the importance to national security, workers of the region pulled together to meet the nation's needs. That tradition of service to the nation continues today. General Chemical, now operating as Honeywell - Metropolis Works, was added to the group of associated plants in 1958 to provide uranium conversion services for the diffusion plant from Metropolis, Illinois.

This mural commemorates the dedication of thousands who worked for better plants, a stronger community and a higher quality of life.

the Dawn of the
ATOMIC AGE

DAFFORD MU

Welcome to the Atomic City

Today, the Paducah Gaseous Diffusion Plant is the nation's only uranium enrichment facility. Operated by USEC Inc, the plant is a global supplier of enriched uranium for electricity production. The Shawnee Steam Plant, on the bank of the Ohio River, now provides electricity to customers throughout the region, as does the Joppa Steam Plant. Honeywell - Metropolis Works provides a variety of chemical products for customers around the world. The U.S. Department of Energy, as owner of the plant, handles site environmental management and cleanup.

This mural commemorates the dedication of thousands who worked for better plants, a stronger community and a higher quality of life.

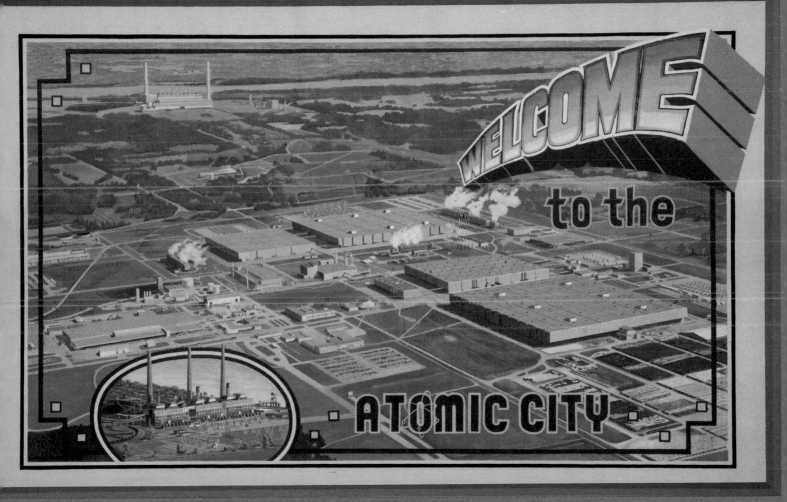

WELCOME to the ATOMIC CITY

Evening Roll Call

The Boy Scouts of America began in February of 1910. During the first year, The Reverend Clinton S. Quin, Rector of Grace Episcopal Church, organized a troop, which his parish sponsored, to serve the boys of Paducah. Troop 1 is recognized as one of the original troops of the Boy Scouts of America and as one of twenty four troops to have been in continuous existence since the beginning.

This mural represents the first 100 years of Scouting by depicting the changes in uniforms and equipment between 1910 and 2010. The mural was inspired by a 1915 photograph taken at Mammoth Cave by Boy Scout George Katterjohn, who inscribed along its margin, "Evening Roll Call". Mr. Quin, the troop's first scoutmaster, is calling the roll of the 120 scouts attending the ten day campout. Each scout was required to earn the money to pay his way to camp. In the early years Troop 1 traveled by train to Mammoth Cave, but by steamboat to reach campsites in Southern Illinois.

For a century, Troop 1 has promoted the principles written in the Scout Oath and Scout Law. Through achievement and outdoor adventure, Troop 1 encourages hardiness, honor, and leadership in each Scout on his journey to manhood.

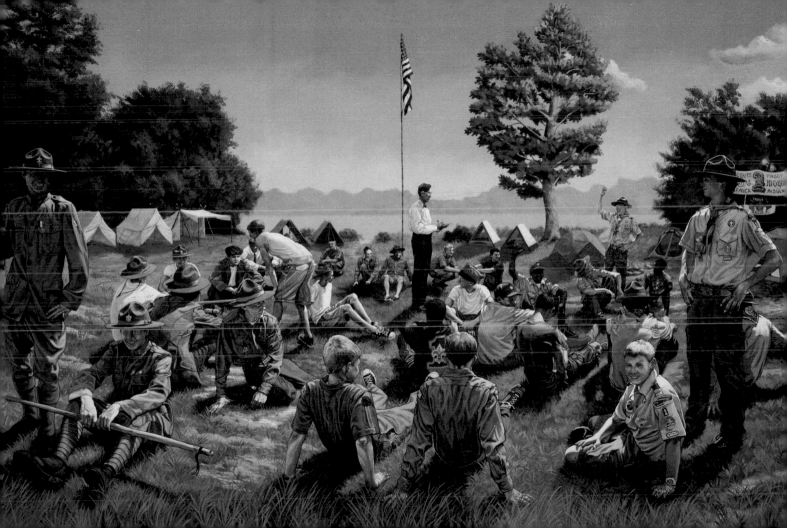

1853 U.S. Marine Hospital

Founded by an act of Congress in 1798, the Marine Hospital Service was the first federal-level mechanism to provide public health care and disease prevention in the U.S. These hospitals were constructed at key river and seaports across the nation to provide health care for merchant marine sailors and to monitor and gatekeep against pathogenic diseases. Over time, the hospitals of the service expanded to provide a key monitoring and gate-keeping function against pathogenic diseases and continued with research and prevention work as well as the care of patients.

Built in 1853, this Paducah location features one of seven, similarly designed by world renowned architect, Robert Mills (best known for designing the Washington Monument). Mills was the first professionally trained architect born in America. The Paducah design was the smaller of two versions, housing fifty patients. Fort Anderson was constructed around the hospital that burned in the fall of 1863.

Sponsored by Gerry Biggs Montgomery to honor her husband, Dr. Wally Montgomery

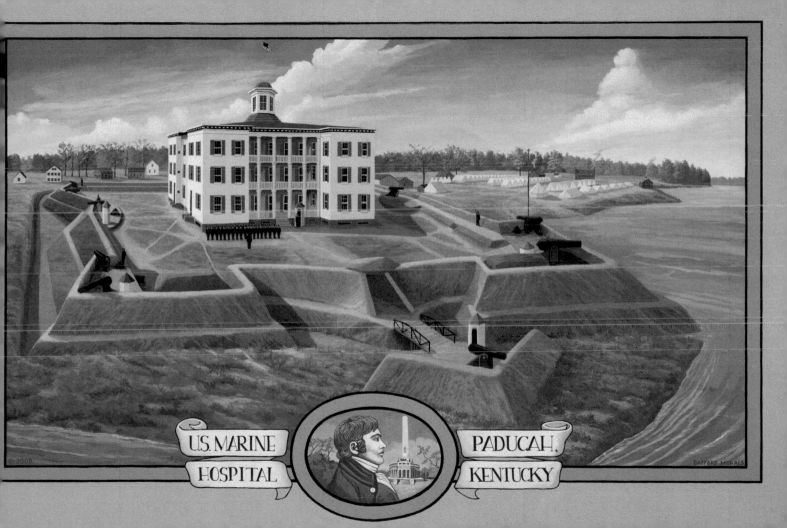

U.S. MARINE
HOSPITAL

PADUCAH,
KENTUCKY

Lourdes Celebrates 100 Years

Riverside Hospital was founded at the Civil War site of Fort Anderson by the municipality in 1905. That location, at the corner of Fourth and Clay Streets, was the hospital's home for many years. The Fourth Street wing of the hospital had to be rebuilt following the historic 1937 flood, and soon after that construction project was completed, the rear wing was destroyed by fire. The Diocese of Owensboro purchased the hospital in 1959 and in September of that year the Sisters of St. Francis of Tiffin, Ohio arrived to manage the facility.

With the change in ownership came a new name: Lourdes, in honor of Our Lady of Lourdes. The small hospital was full the day the sisters arrived. A diary kept in those years recorded that Sister Gerard unexpectedly delivered a baby one evening soon after moving to Paducah, "and now feels very much at home".

In 1973, Lourdes moved from the downtown location to the beautiful new building on Lone Oak Road. The Marshall Nemer Pavilion, named in memory of a long-time hospital board member and volunteer, opened in 2004. In 1991, the Sisters of Mercy became sponsors. In 1997, the Sisters of Mercy joined other systems to form Catholic Healthcare Partners.

Sponsored by Lourdes

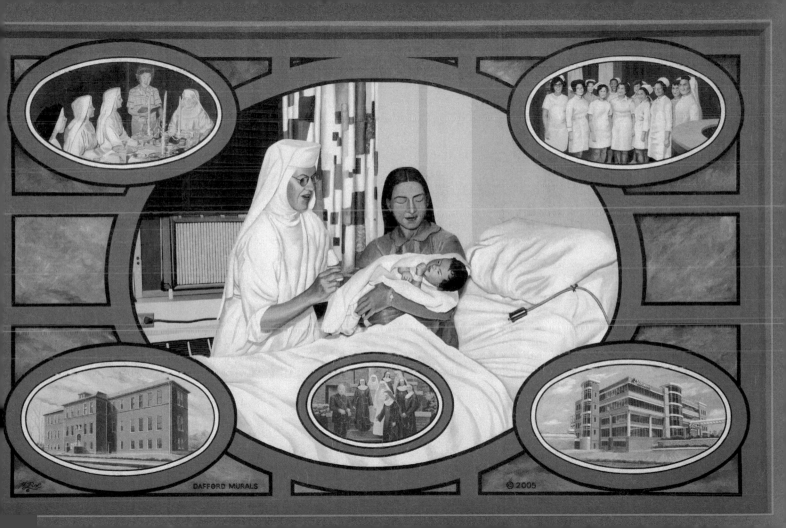

DAFFORD MURALS © 2005

A Century of Library Service 1904-2004

This Carnegie Public Library opened at 826 Broadway in October 1904 with a grant of $35,000 from Andrew Carnegie. The book collection contained 1,800 volumes. The Library served at this location until a fire in 1964 forced it to move into temporary quarters at 707 Broadway.

The Library was reorganized as the Paducah Area Public Library in 1966 and in 1970 opened in new facilities at 555 Washington Street as the Paducah Public Library. The Fiscal Court formed a Library District in 2000 changing the name to McCracken County Public Library.

Sponsored by the Friends of McCracken County Public Library.

Funded by the people of the community who responded to the call: "Remember the Carnegie"

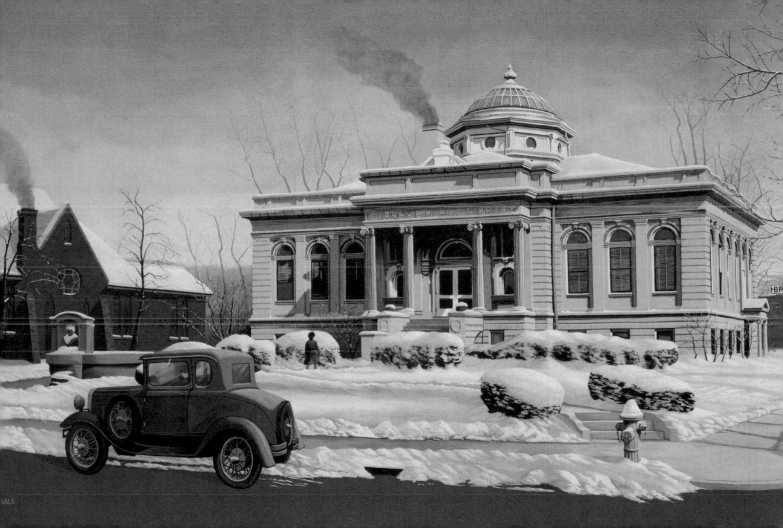

RALS

Labor Day Celebration

Union labor helped build Paducah, including the floodwall on which this mural appears. Unions in construction, business, industry and government helped create a large middle class in Western KY especially after World War II. The region's earliest unions date to the 19th century. In 1892, the American Federation of Labor chartered the Paducah Central Labor Council, an association of local unions. The next year, the CLC, the ancestor of the Western KY Area Council, AFL-CIO, sponsored the city's first Labor Day Parade, which became the annual end-of-summer procession featured on this mural.

It is one of the oldest Labor Day parades in the country and for several years was the official KY State AFLCIO Labor Day celebration. W.C. Young, a national labor and civil rights leader, appears above the "T" on the banner along with other local labor leaders. The Area Council during the presidency of Glenn Dowdy approved the mural.

Sponsored by the Working Men & Women of Western Kentucky Area Labor Council AFL-CIO and Affiliate International Unions

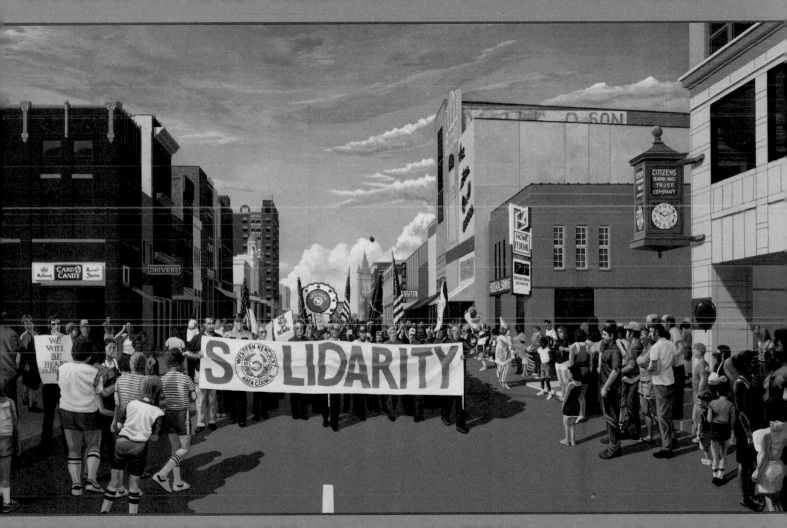

Western Baptist Hospital
50 Year Celebration

On a warm Sunday afternoon in October 1953, Western Baptist Hospital was dedicated as the newest and most modern facility in Kentucky. The foresight of the original seven-member commission, formed in 1945, created a strategically important cornerstone in the Paducah community. The hospital met an immediate need to support the population increase associated with the newly opened Paducah Gaseous Diffusion Plant.

As Paducah has grown and changed through the years, Western Baptist has continued to evolve from a community hospital to a regional referral center, providing leading edge technology and specialized services to improve the quality of people's lives. This commemorative 50th Anniversary mural celebrates our history and honors the men and women who have invested their lives and their hearts in the healing arts.

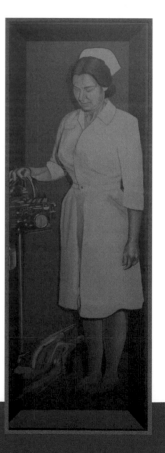

Sponsored by Western Baptist Hospital

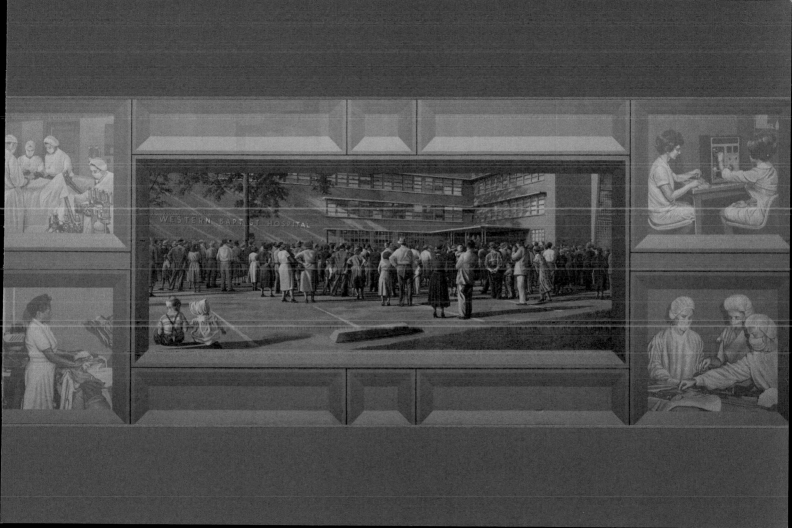

Paducah Coca-Cola Bottling Company Building

Paducah Coca-Cola Bottling Company was founded in 1903 by Luther F. Carson. The business moved into this landmark building at 32nd and Broadway in 1939. The building was designed by Lester Daley of Metropolis, Illinois. The lighted dome colorfully graced the night skyline for many years. In 2003, thousands of people toured the building during the centennial celebration of 100 years of Coca- Cola bottling and distribution in Paducah. Coca-Cola ceased operating in this facility in 2005.

Sponsored by Jane and Louis Myre

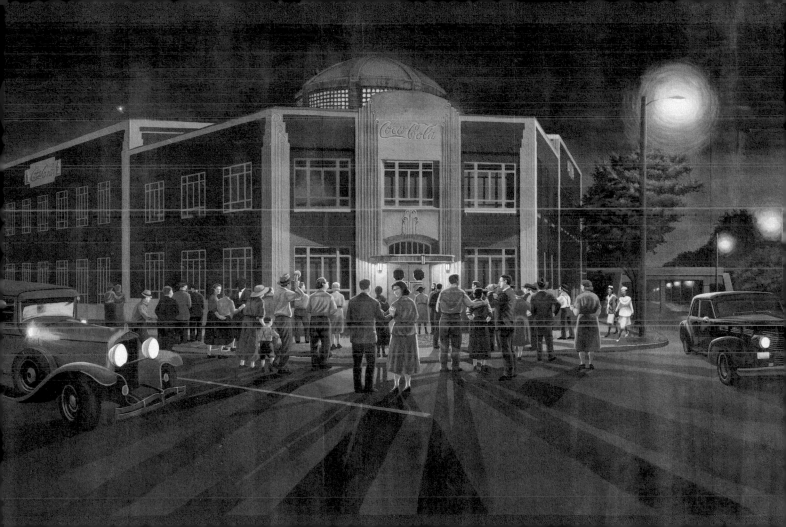

ROBERT DAFFORD, MURALIST

Robert Dafford originally came to Paducah in the fall of 1995 on invitation from Kelly Haskins Hack on behalf of the City of Paducah. Bill Schroeder, an influential Paducah businessman, and the Paducah-McCracken County Visitors Bureau encouraged the city planners to seek out this renowned muralist. The Gus Ed Hank and Dick Babbitt families had seen his giant clarinet painting in New Orleans and had returned home to Paducah raving about his work. The purpose of his original visit was to advise the city about the viability of painting on its floodwall which borders the city's historic downtown. The west-facing wall gets a huge amount of afternoon sun and the extreme damp, windy and fluctuating temperatures were a concern for the city and interested sponsors.

Dafford, a resident of Lafayette, Louisiana, fell in love with the city on his first visit. After being introduced to several local citizens and learning about Paducah's history, he stated, "This river town has vast and colorful history and would be an ideal location to paint images from its past". He and his team of talented muralists were commissioned to begin painting Paducah's floodwall the following spring. Dafford has painted over 500 murals across the United States, Canada, France, England and

An Artist at Work

......................................

Muralist Robert Dafford at work on his masterful 50+ murals project along the Ohio River in downtown Paducah, Kentucky.

Photo by Ro Morse

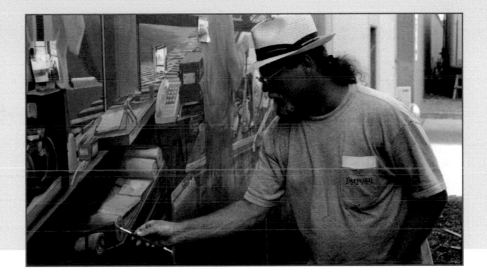

Belgium. He has been painting murals, signs and fine art paintings for over 50 years. In the past 40 years, Dafford has concentrated on working along the Ohio River, painting over 200 large historical images of cities on their floodwalls, using trompe l'ceil, advanced perspective, and realist technique. Many riverboat and motor coach tours make stops along the Ohio River specifically to see these murals. The Dafford Murals are created with the purpose of boosting downtown development in small communities. Paducah's extraordinary 50+ mural panels are certainly a tremendous attraction for anyone who visits its revitalized downtown.

HERB ROE, MURALIST

"After high school, I attended the Columbus College of Art and Design for a year. When I returned home to Portsmouth, Ohio for the summer, I met Robert Dafford and began working for him as a summer job on the then newly commissioned Portsmouth Floodwall Mural Project. That fall, Mr. Dafford asked if I'd be interested in working for him for a year instead of immediately returning to school at C.C.A.D. I decided to take a year off, and it turned into many more, and what began as a summer job turned into a lifelong career.

In my third year working for Dafford Murals, we began our work in Paducah, a town I've grown to know and love over the years. Although I'd continued to work on my own art, which ranged over a variety of subjects and mediums, in 2007 I struck off on my own with ChromeSun Productions. It's given me the freedom to work more on my own designs and commissions, to further pursue the career in art that I've worked for since I was 12 years old. Since my departure from Dafford Murals, I've worked closely with them and with the Wall to Wall committee to stay an active participant in the Paducah Floodwall Mural Project. I believe I've done some of my best work here and can't wait to see what the project holds in the future."

A Lifetime of Art

Muralist Herb Roe at work in Paducah, a town he's grown to love.

Photos by Ro Morse

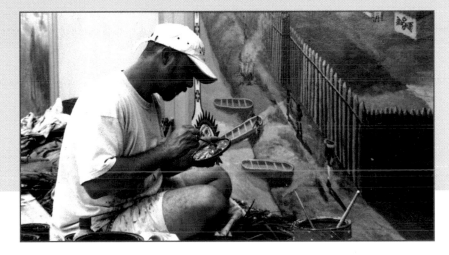

Herb and Rachael

Dafford Muralist Herb Roe, assisted by his daughter, Rachael, refurbishes borders on the Civil War-Battle of Paducah mural. 2010 concluded painting new images on the floodwall in the three blocks on the city-side of "the wall" and maintenance of the existing project began. Herb spends a couple of months a year in Paducah and has been in the center of Paducah's floodwall mural project since its conception in 1996. Extensive research and serious attention to detail are considered the rule of thumb when these artists paint a city's history.

Robert Dafford and Herb Roe, painting and maintaining their work through the years.

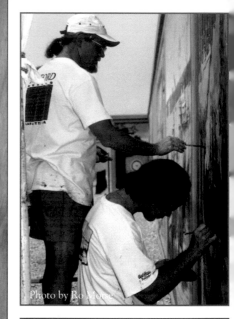

Photo by Ro Morse

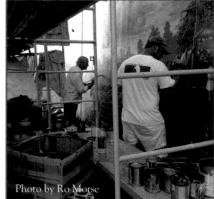

Photo by Ro Morse

Photo by Nathan Brown

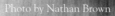

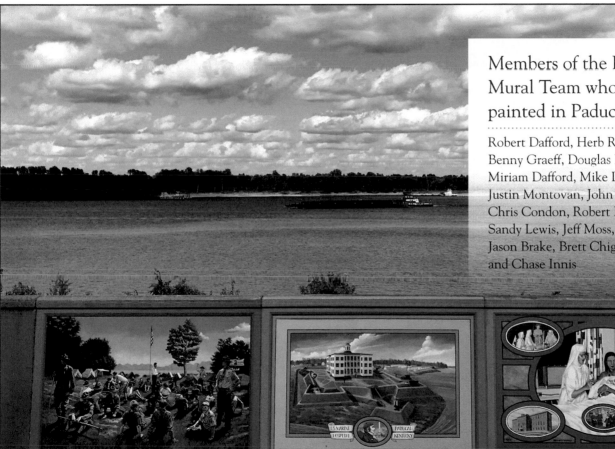

Members of the Dafford Mural Team who have painted in Paducah:

Robert Dafford, Herb Roe, Benny Graeff, Douglas Dafford, Miriam Dafford, Mike Doherty, Justin Montovan, John Norris, Chris Condon, Robert Baxter, Sandy Lewis, Jeff Moss, Jason Brake, Brett Chigoy, and Chase Innis

Preserving History

Bill and Meredith Schroeder,
along with Mayor Albert Jones and
Mural Advisory Board members,
exchange documents in celebration
of the project's impact on historical
preservation and the tourism industry
in Paducah and Western Kentucky. >

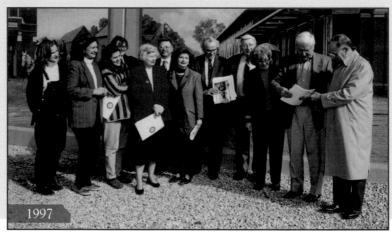

1997

Photo by Paducah Convention & Visitors Bureau

This creative project, which focuses on Paducah's history, would
not be possible without the generous and devoted support of Bill and
Meredith Schroeder and Schroeder Publishing, Inc. Their faithful
commitment to the preservation of the past and vision for the future
are enormous assets to this western Kentucky community and the entire
region. Their original contributions and continuing support of Paducah
Wall to Wall are priceless.

*< Bill Schroeder joins Robert Dafford during a planning session at the Visitors Bureau in 1997
as the time line for Paducah's Mural Project was unveiled. Photo by Ro Morse*

A True Legacy

Bill Black, Jr. (1946-2017) shares the history of the 1905 Market House, Fire House and Paducah's native sons, Alben Barkley and Irvin Cobb during a tour of the mural project.

Photos by Paducah Convention & Visitors Bureau

History Comes Alive

One of the most exciting aspects of this project is the interest it ignites in students of all ages. Whether alone or as a part of a guided tour, students and visitors alike see the region's history in a new and intriguing perspective.

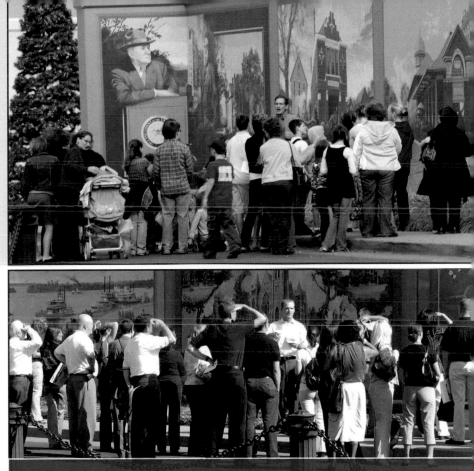

Fowler Black, Group Tour and Convention Director with the Paducah Convention & Visitors Bureau, captivates the crowd in this guided tour of the Floodwall Murals.

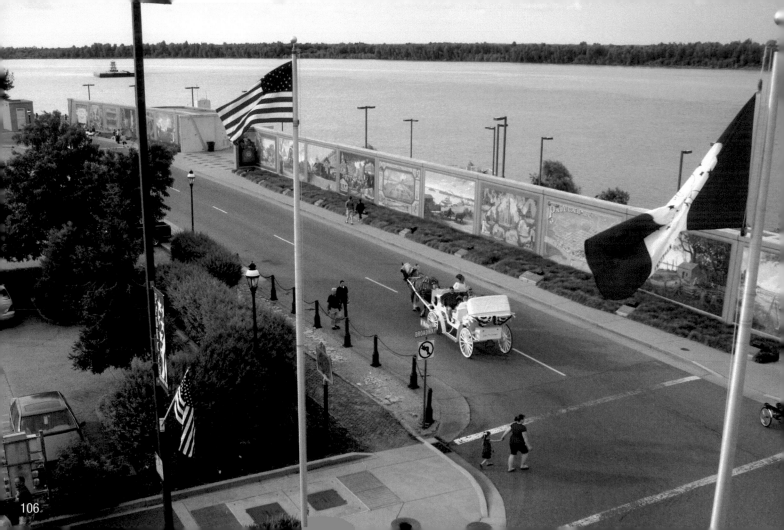

Original Block of Mural Project on Water Street

The renowned Dafford Muralists capture Paducah's rich history in paintings on this UNESCO Creative City's floodwall overlooking the confluence of the Ohio and Tennessee Rivers. This visionary project began in the spring of 1996. The first twenty-panel time line was completed in 2001 and the last painting in the three block section in 2010. The city's most visited 24/7 art and history attraction intrigues thousands of fascinated onlookers each season.

Photos by Paducah Convention & Visitors Bureau

Southern Most Section of the Dafford Mural Project >

with the confluence of the Tennessee and Ohio rivers in the background.

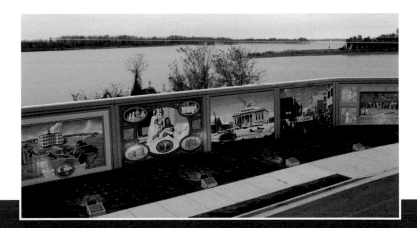

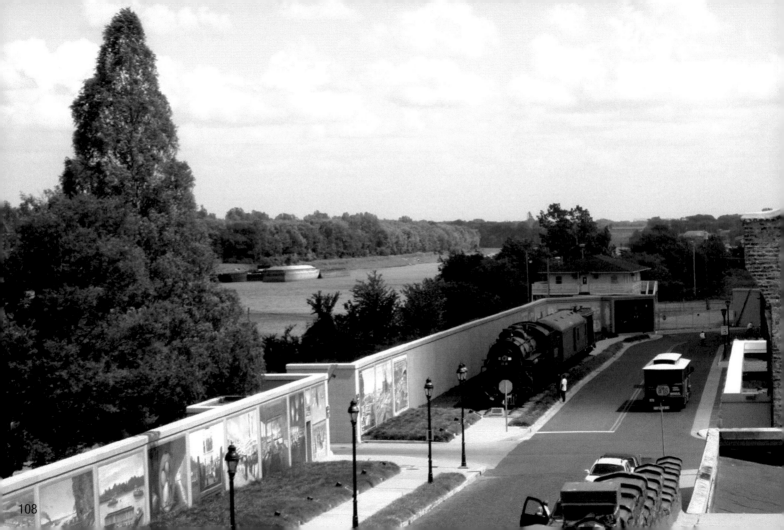

Magnificent Art & Beautiful Views

Along Water Street, from Broadway south to Kentucky Avenue, Paducah's rich and vibrant river history is portrayed in a full block of colorful images, displayed chronologically beginning with the early native Indian heritage to present-day river activities. The location of this particular section was ideally chosen as the River Discovery Center (in the oldest standing building in downtown Paducah) and the Seamen's Church Institute, Center for Maritime Education are right across the street. Paducah's original establishment at the confluence of the Ohio and Tennessee Rivers remains a vital part of the city's success and productivity. The thriving river industry, which stayed mostly hidden behind the 12.5 mile earthen and concrete floodwall for decades, is becoming more visible. State-of- the-art regional headquarters have been and are being constructed on the city side of the wall. Presently the most historic, as well as the most contemporary representations of this river city's history, come together along Paducah's riverfront.

Horse drawn Carriages and Paducah's Downtown Trolley transport curious tourists and locals on tours of the panoramic floodwall murals. *Photos by Ro Morse*

109

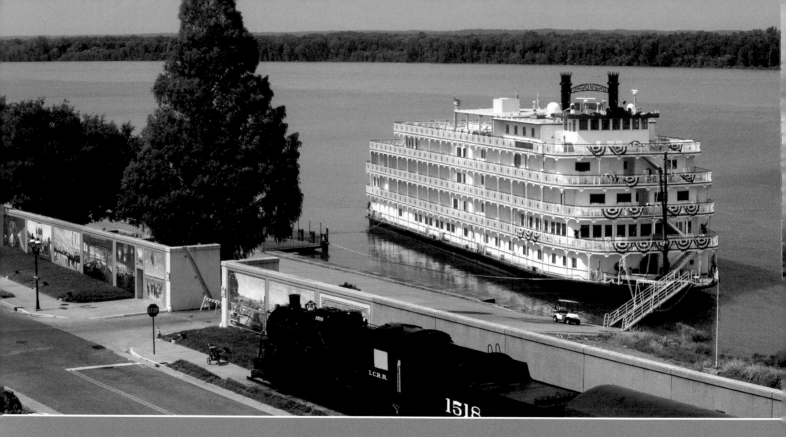

The docking of steamboats brings hundreds of visitors, eager to view the Paducah Wall to Wall project. As the river city's history is revealed in vivid images, tourists leave with lasting memories of our region's rich heritage. *Photo by Bill Fox*

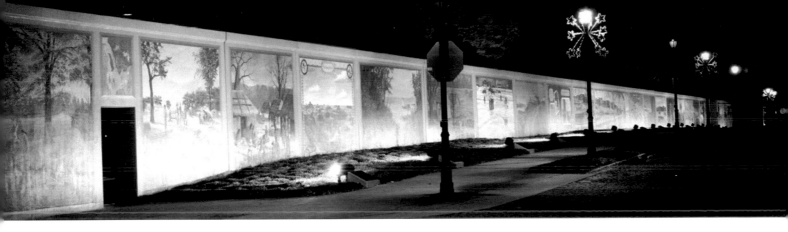

As Paducah's most popular 24/7 art history attraction, the floodwall murals invite visitors and locals alike to view and read all about this river city's rich and colorful history anytime - day or night. The one liner, "Bright Star on the River" certainly describes these images, especially when showcased after the sun sets as they glow like a shiny border, framing the images along Paducah's riverfront.

The Interpretive Panels project is a joint effort with the private and public sectors in the community. Paducah Wall to Wall, Inc. appreciates the continuing assistance of Troy Holshouser who builds and installs the uniquely designed concrete bases for the bronze interpretive panels in front of each mural. Thank you to Schroeder Publishing for their cooperation in support of this project. *Photos by Ro Morse*

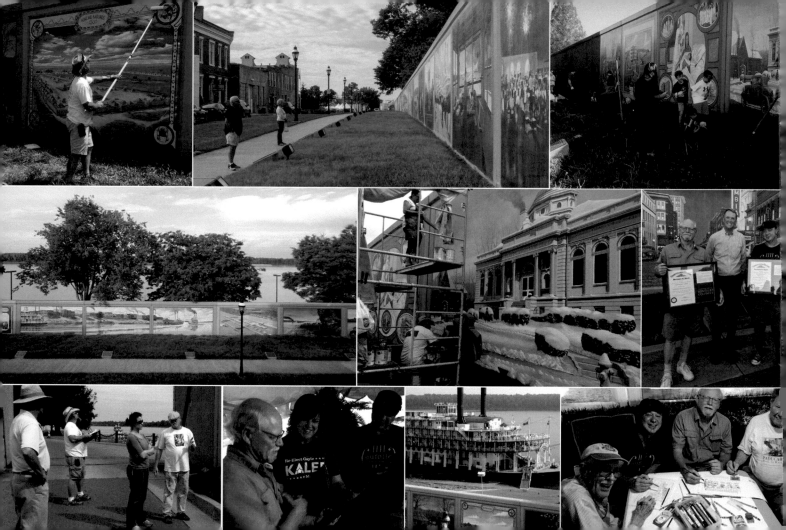

Lighting.
The City of Paducah supports the project by providing individual spot lights which illuminate the paintings when the sun goes down each evening. All three blocks have well maintained, lighted sidewalks for safe access 24/7.

Scaffolding.
Paducah Scaffolding generously supplies the scaffolding that the artists use as they paint and maintain the project.

Tours.
The Paducah Ambassadors host walking tours for local citizens, visitors, motor coaches, garden clubs, civic groups, class reunion groups, students, and steamboat passengers. The history they share is colorful and memorable. Bronze interpretive panels in front of each mural also provide helpful insight for self-guided tours.

General Project Coordination.
The all-volunteer board of Paducah Wall to Wall, Inc. coordinated the research and sponsorship of each mural. Dafford Muralists designed and painted all the copyrighted images in the three blocks on Water Street. Thanks to the City of Paducah, an arrangement for annual maintenance is in place to ensure the integrity of these murals for future generations.

< **Left to Right, Top to Bottom:** (1) Herb seals the newly repainted Kincaid Mounds mural. (2) Tourists taking a self-guided tour (3) A group of volunteers young and old works on landscaping maintenance (4) View of the Ohio River with our beautiful murals in the foreground. (5) A Paducah School of Art and Design student gets hands-on painting experience with Herb (6) Robert and Herb are honored to be named Kenucky Colonels by Col. Hal Sullivan (7) Robert Dafford and Herb Roe discuss details with City Parks Director Mark Thomson and Amie Clark (8) Robert and Herb receive "Duke of Paducah" honors from then-Mayor Gayle Kaler. (9) One of many steamboat visits to the Port of Paducah, KY (10) Artist Bill Ford discusses his Wall to Wall Coloring book with Herb, Robert and Jack Johnston.

The Paducah Wall to Wall Project

The Paducah Wall to Wall Project is a joint venture sponsored by the region's private sector: individuals, families and businesses. The City of Paducah supports the project by providing annual mural maintenance, landscape care, sidewalks and lighting for the murals (funded during Mayor Gerry Montgomery's administration and set aside for downtown riverfront redevelopment – proceeds from a Kentucky state economic development bond issued in the early 1990s and the current City infrastructure budget).

This 25th Anniversary Publication

Graphic Designer and Paducah native Nathan Brown is the featured photographer, designer and creative eye for this 25th anniversary publication of Paducah Wall to Wall images and history.

Printing of this publication was done by Paducah Printing Corporation.

Souvenirs and Promotional Merchandise

Periodically, Paducah Wall to Wall, Inc. issues posters and signed, limited edition art prints.
Each edition features a large reproduction of a selected mural image.

Also Available are T-Shirts, Note Cards, Books, Coloring Books and Postcards.
All proceeds from the sales of mural merchandise benefit future mural maintenance.

For locations of mural merchandise or to support mural maintenance, contact:

Paducah Wall to Wall, Inc.

270-519-1321 | info@paducahwalltowall.com | www.paducahwalltowall.com

Paducah Wall to Wall, Inc. directs all decision making concerning subject matter and historical accuracy for the paintings.
All Paducah Wall to Wall mural images are copyrighted by Dafford Murals. Reproduction for profit without permission is prohibited.

Sincere thanks to Bill and Meredith Schroeder for their support and willingness to create and work with Paducah Wall to Wall from day one. Their ability to reach out and pull families and businesses together to create this 24/7 public art and history project has provided our region with a magnificent jewel on our downtown riverfront. Bill (1931-2017) was always confident in the future of this project.

120

Photo by J.T. Crawford